Philadelphia:
Finding the Hidden City

Philadelphia: Finding the Hidden City

Joseph E. B. Elliott, Nathaniel Popkin, and Peter Woodall

Temple University Press
Philadelphia · Rome · Tokyo

For copyright data and
Library of Congress
Cataloging-in-Publication Data,
see page 186.

CONTENTS

Markers of the Hidden City

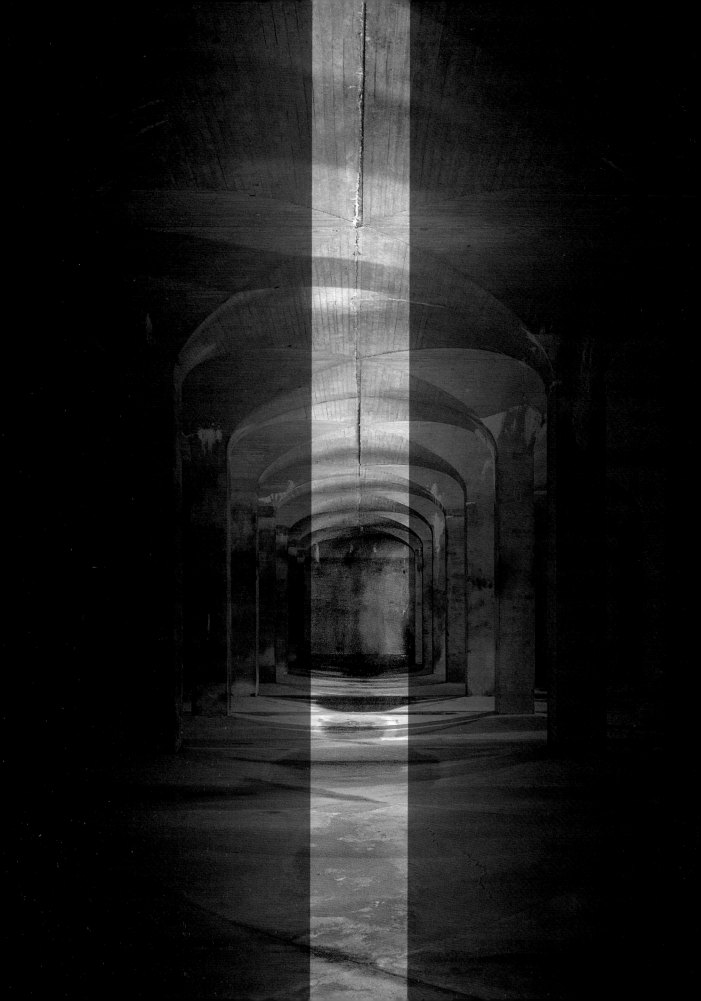

In June 1916 the 442 members of the Poor Richard Club, publishers and advertising men, hosted a trade convention of the Associated Advertising Clubs of the World. The Poor Richard Club occupied a "little home," as members called it, next door to the nation's oldest amateur artist group, the Sketch Club, on Camac Street, a slender alley of cobblestones and roomy nineteenth-century row houses turned into clubhouses. A century later, with the alley draped in gingko trees, a law firm occupies the Poor Richard Club (its members moved to a much larger building around the corner in 1925). Yet several other nineteenth-century clubs—including the Sketch Club, the Plastic Club, and a literary society called the Franklin Inn Club— remain on Camac, "little Bohemia," as it was known in 1916, hidden inside the commercial heart of present-day Philadelphia.

Advertising men are natural civic boosters. With their out-of-town guests in mind, the members of the Poor Richard Club published a guide, the *Poor Richard's Dictionary of Philadelphia* (1916), assembled by the artist Frank Taylor, a magazine illustrator. One of Taylor's employers, *Harper's Magazine*, had just published a needling article, "Who Is a Philadelphian?" by the playwright Harrison Rhodes. Philadelphia, Rhodes proffered, was "a *terra incognita*":

> It makes no effort to attract the stranger. It advertises no historic attractions, it sets no Broadway ablaze, it beats no tom-toms.

Particularly optimistic about his city, Taylor was sensitive to claims like this and to accusations, mostly by New Yorkers, that it was "slow" (the previous year he had produced a lithograph series he called "Ever-changing Philadelphia"). "As in many other cases the facts spoil the joke" about Philadelphia's slowness, he wrote in the introduction to the guide, which begins with a 166-item list of Philadelphia's pioneering "firsts."

Taylor, whose watercolor sketches and lithographs make up our best record of Philadelphia streets in the late nineteenth and early twentieth centuries, wanted his city to be seen for what it was: a rich, quilted tableau of people and buildings, at human scale, both "busy" and "homey." Luc Sante, in *The Other Paris* (2015), writes that before the telephone, radio, and television, city streets were public living rooms legible to their observers: "The relative intimacy of a city, any city, of a hundred or more years ago is as hard to overstate as it is to convey." Taylor's scenes—which depict people gathered in streets, beneath store awnings, and in the glow of electric lights—recall this same sentiment.

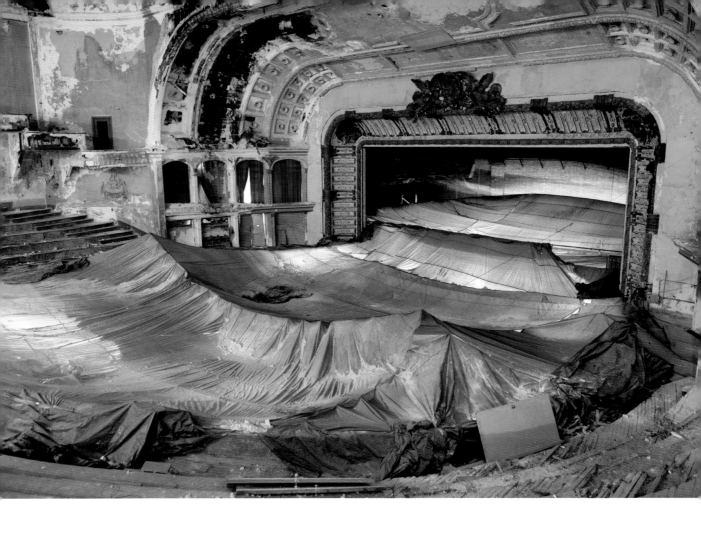

Plate I.1
Metropolitan Opera House,
North Broad Street, 2009 (HCF)

Like Paris, Philadelphia had a population in 1966 (about 1.95 million) that was slightly higher than it was a half century earlier in 1916 (about 1.75 million), but spread across a much greater area. The new neighborhoods in the farthest reaches of the city were built at lower density. In the concentrated traditional city that persisted until World War I, most people lived in the same neighborhood where they worked, ate, and shopped. Sante avers that this was true for rich Parisians as well as poor and that, in fact, people of all economic classes were joined in place. "The rich were right over there, in the next street," he writes—as true of Philadelphia in that period as Paris.

In Philadelphia in 1916, an abundant portion of both rich and poor people were involved in making things, Taylor was proud to declare in *Poor Richard's Dictionary of Philadelphia*. They worked in the city's 8,379 plants, factories, workshops, and mills, and their output was stunning. Taylor cheekily illustrated all this activity under the heading "Philadelphia's Time-Table," as if, in this exceptional place, time was measured in productivity in accordance with the theories of Scientific Management (invented by another Taylor of Philadelphia, Frederick, and just then gaining wide acceptance). "When Philadelphia gets into its working togs," Frank Taylor wrote, "it strikes a gait like this":

Every second, 15 cigars.
Every second, 10 loaves of bread.
Every second, 10 pairs of stockings.
Every second, 15 bushels of wheat loaded.
Every second, a new saw.
Every second, 1½ yards of carpet.
Every second, 50 daily papers printed.
Every two seconds, a new hat.
Every three seconds, a pair of lace curtains.
Every twenty minutes, a new house erected.
Every hour, a new trolley car built.
Every two-and-a-half hours, a new locomotive constructed.

About a half century later, in the early 1960s—a good decade into the suburbanization that would dilute the intimacy of Philadelphia and the deindustrialization that would drain it of purpose, rhythm, and wealth—the writer and composer Nathaniel Burt produced a study of Philadelphia's legacy upper class, *The Perennial Philadelphians* (1963). The nominal subject of Burt's book was the city's unusually insular and long-lived hereditary aristocracy, which until the end of the long nineteenth century, around 1916, embodied the civic ambition of Philadelphia. Now, several decades later, Burt discovered that by a ratio of ten to one, the members of this atrophied group lived outside the city, subject to the same process of white flight that emptied out many other postwar American cities. Philadelphia's

wealthy remained "conspicuous" because of their outsized influence in business and society but, at the same time, were eerily "absent" from the bristling life of the city.

In the course of recounting the achievements of these illustrious families—the Biddles, Cadwaladers, Ingersolls, Whartons, and the like—over the course of two centuries, Burt explained better than perhaps any writer before or since the essential qualities that made the city of Philadelphia characteristically itself. Compared with the forward-looking American cities of the time, he noted, Philadelphia was decidedly too inward, too drowsy, and too parochial. Yet those very qualities had, in their abundance, given the place an elusive character that was "not quite like everything or anything else":

> It was neither exciting like Manhattan, quaint like Boston, nor picturesque and glamorous like the South and West. It was not even conspicuously awful like the Midwest. It was, in fact, like some forbidden Oriental city ... surrounded by its own impenetrable wall.

This made Philadelphia, according to Burt, the "Hidden City." More than fifty years later, his words still ring true to us, although for somewhat different reasons. For Philadelphia seems to possess an exceptionally large number of places that have disappeared elsewhere—workshops and small factories, sporting clubs and societies, synagogues and theaters and railroad lines—like endangered species that have managed to stay alive in some remote forest or swamp.

SURVIVING LAYERS

The Philadelphia of the 1960s, Burt posited, was an inscrutable, isolated, impenetrable "black fossil" of the productive industrial machine Frank Taylor had described in 1916. In the fifty years between Taylor's work and Burt's, what happened to the wealth of the city's billion-dollar "made in Philadelphia" economy? The various redevelopment schemes of the 1950s and 1960s cleared large swathes of the oldest sections of the city, and thousands of buildings burned down or became so decayed that they were demolished in the decades that followed. But some of the remains of the long nineteenth century survived, and that is, in many ways, a darker story. The total value of real estate and personal property in the city dropped from almost $5 billion in 1930 to $3 billion in 1944. The descent of much of Philadelphia into poverty and the growing worthlessness of much of the city's real estate had the effect of preserving a great deal of that world in what might be called an imaginatively suggestive state, neither torn down, as it might have been in New York or perhaps Chicago, nor restored to the kind of sterility that cannot be overcome by leaving a few gantry cranes in

place in an industrial-turned-loft building. Philadelphia's stultified economy of the 1930s and 1940s, only temporarily relieved by defense contracts during World War II, produced almost no investment in redevelopment, and its sclerotic Republican political machine, known as the Organization, allocated scant funding for public works.

Burt didn't see the charm in the decadence. He saw instead a city abandoned by the source of its civic wealth, people who had fled the city and left it beached on the sand like "a fresh-water whale wedged up on the silt between two dirty rivers." Perhaps overly eager to ascribe to the entire city the traits of its upper class (Rhodes, writing in *Harper's Magazine* in 1916, made the same elision), and perhaps not inclined to experience the city from a different perspective, Burt (Princeton Class of 1936) attributed the "disreputable snaggle-toothed obsolescence of so much of Philadelphia's real estate" in the early 1960s to the negligence of its upper class, "shielded from the sight of what their absence has done to their fortunes." Yet what managed to survive from 1916 to 1966 to 2016 often did so in part because the people who gave the firms or institutions or clubs life—only some of them, despite Burt's assertions, actually members of the upper class—did not entirely abandon the city when they moved to the suburbs, but rather pursued what a Philadelphia blogger, Patrick Hildebrandt, calls the "long goodbye." They kept those institutions alive, if barely, by returning to the Racquet Club for court tennis tournaments, their parish churches on Sunday mornings, and their dwindling factories in North Philadelphia during the workweek. Unwilling to relinquish the bonds of family, memory, and identity, they constituted an uncoordinated, unintentional force for preservation through inertia. While the financier Stephen Girard and the scientist William Wagner kept the past alive from beyond the grave through detailed wills and mountainous endowments, the fifth-generation owners of John Stortz and Son, Inc., kept their tool-making factory in Old City on a kind of remote-controlled life support.

As far back as the mid-1940s, the journalist John Gunther wrote in *Inside U.S.A.* (1947) that "Philadelphia retains some remarkable atavisms." The city's glassed-in air was stifling, but it seemed to slow the process of decay. Thus in Burt's time, and still today, a half century later, "quaint" survivors from an earlier age endure: a patinated parallel universe of social clubs, rowing clubs, singing societies, drama clubs, military troops, workshops, and athletic associations. This is our good fortune. These institutions deepen and enrich our urban experience by drawing the past into the present. Members of the Racquet Club, still among the economic and social elite, play two archaic sports, court tennis and racquets.

In this way Philadelphia became, in the late twentieth century, a place of remarkable contrasts. Astounding levels of poverty and dissolution surrounded some of these clubs, factories, and churches; others merely went on, cheek by jowl with the working-class masses. Either way, their legacy

owners, members, and worshippers did not advertise their presence; indeed, in many cases they took pains to conceal it. For those not directly concerned with them, which is to say almost everyone, their existence was largely unknown, unsought, and, even when physically seen, unrecognized, because no one suspected (or even dreamed) what might be inside their walls.

The remains of the long nineteenth century—with its emphasis on materials, its alluring buildings, and its looms, libraries, furnishings, lathes, turbines, boilers, spools, and pumps—beg to be seen. Present-day Philadelphians, with an eagerness to discover and engage, have inherited hundreds of architecturally impressive mills and factories, schools, theaters, churches, and civic buildings, some restored, others abandoned or underutilized, prizes of Philadelphia's postindustrial inertia.

There is another reason why so much of the city's long nineteenth century remains: Philadelphia has never experienced catastrophic change. The city's population tripled in size in the fifty years following the outbreak of the Civil War, but instead of wrecking old neighborhoods and districts, most of that growth radiated outward, consuming raw meadow, forest, and farm field. By 1910, some 1.54 million people lived in Philadelphia. Then, the mass immigration from eastern and southern Europe that had begun in the 1880s accelerated. African Americans, seeking escape from Jim Crow in the South, headed across the Mason-Dixon Line. Proportionally more of these migrants—predominantly from Maryland, Virginia, South Carolina, and Georgia—settled in Philadelphia than in any other city of the North. The city's population blossomed to almost 2 million in 1920 and held steady until white flight and deindustrialization began in earnest in the 1950s. By 2000, the city's population had fallen below the 1910 level. The depletion could have been much worse—indeed catastrophic. Instead, assertive 1960s-era policy sought to preserve Philadelphia's manufacturing base and keep factories and mills operating. Maintaining industrial employment into the 1980s, even at reduced scale, delayed an aggressive economic adjustment that happened much sooner in Boston and New York. The prolonged real estate depression in many neighborhoods obliterated demand for land and access to capital, insulating those neighborhoods from rapid destruction. Simultaneously, civic leaders and real estate developers fostered a revival of core areas of Center City and University City, which acted as a bulwark against a Detroit-scale collapse. Major and minor Philadelphia institutions embraced tradition as a way to survive, and their perseverance extended the long goodbye. Strong early preservation ordinances discouraged demolition in favor of restoration and reuse. The sheer abundance of its nineteenth-century patrimony meant that Philadelphia could surrender thousands of buildings without sacrificing its characteristic form. All that has allowed Philadelphia to collect and accumulate rather more than it devours and destroys.

Plate I.2 (opposite)
City Hall, north portico, 2016

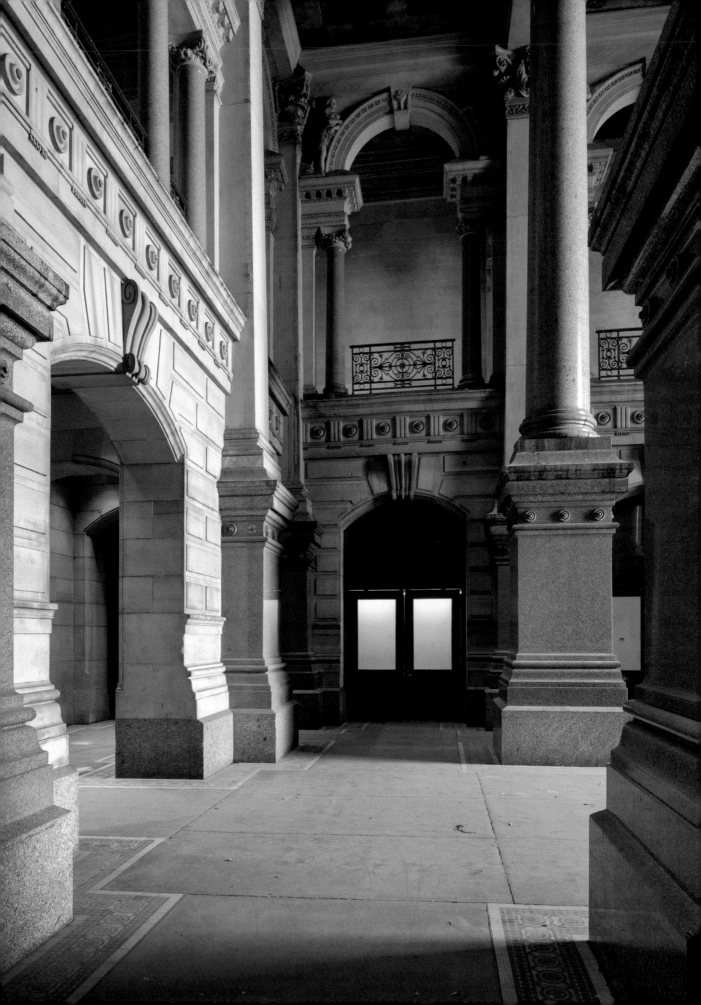

Renewed immigration, starting around 2005, reversed population decline, and since then Philadelphia has been growing again. According to the 2010 U.S. census, the city's population was almost exactly the same that year as it was a century before. The flat line masks boom and bust, but it also points to the city's static quality, particularly in comparison with the high-growth cities of the South and West, and even New York, which nearly doubled in size between 1910 (4.76 million people) and 2010 (8.17 million). Growth on New York's scale could be accommodated only by what the urban historian Max Page sees as "creative destruction," a constant churn of development, demolition, and redevelopment, ever more intense in use and grand in scope. Chicago, destroyed by fire in 1871, experienced a more catastrophic kind of change, as did San Francisco, wrecked by earthquake in 1906. Both cities had to be almost completely rebuilt. In Chicago, the extent of destruction and the willful force of rebuilding inculcated a culture of redevelopment that was quite different from Philadelphia's style of incremental change.

A city of accretion, Philadelphia is not a dynamic city, in the manner of New York, nor a collapsed city, like Detroit, nor a city where much of the past has been polished like a family heirloom, as in Boston or Charleston. Rather, Philadelphia embodies some elements of each. Like New York, Philadelphia takes its energy from immigrants and economic innovation and a brisk East Coast pace. Like Detroit, Philadelphia has experienced an industrial collapse that emptied factories and mills and produced seemingly intractable racialized poverty. Like Boston and Charleston, Philadelphia has taken special care to preserve landmarks and streetscapes of a definitive historical period, while leaving the bulk of the city, built in the long nineteenth century, without legal protection.

The fact that Philadelphia isn't fundamentally a dynamic, ruined, or polished city, but incorporates some combination of all those qualities, has cost it traction in the national imagination, which craves singularity. If New York is the city of wild dreamers, as the architect Rem Koolhaas asserts in *Delirious New York* (1978, reprinted 1994), and Los Angeles is the city of exclusion, as the sociologist Mike Davis concludes in *City of Quartz* (1990), and Detroit is the city of dystopia, as the photographer Andrew Moore reveals in *Detroit Disassembled* (2010), what is Philadelphia?

Keeping its layers hidden in the accretive cityscape, Philadelphia itself is hidden, sandwiched between New York and Washington, D.C., and removed from the contemporary narrative of the United States. And yet, until about 1925—when its financiers could no longer keep up with New York's and its provincial political machine stopped producing leaders of national ambition—it was central to that narrative. Philadelphia's cultural zeitgeist is (usually, though not always) prone to reticence; it hides its wealth and guards its influence. The many lives of the city are hidden down narrow streets and alleys and behind the brick façades of row houses,

one barely distinguishable from the next. For these reasons Philadelphia is naturally, and characteristically, the Hidden City.

Painting something as complex as a city with such a broad brush produces conclusions that are both true and not true. This so-called Hidden City produced more wealth than nearly any other place on earth during the long nineteenth century, and Philadelphians celebrated their wealth by constructing castles that were very easy to see, including a gargantuan city hall meant to be the tallest building in the world. In the twentieth century, Philadelphians pioneered technology, packed into speakeasies, and filled their city with movie palaces, some of the most ostentatious and exuberant in the United States. Taylor's *Dictionary of Philadelphia* lists brewers, rooftop beer gardens ("good fare, good music, and merry company"), playhouses and "motion picture" theaters, minstrel shows, restaurants and cafes in hotels and department stores, and the dozens of passenger and freight railroad and ship lines that connected the city to the world, and sailors to the streets, taverns, and brothels of the city's red-light district. With some eight thousand speakeasies and thirteen hundred taverns selling illegal alcohol, no city was wetter during Prohibition than Philadelphia. Boisterous public life has marked the city from the start, hardly the characteristic of a reticent place.

But even Taylor knew that something slow and quiet about Philadelphia made it less public and therefore more hidden in character than other cities. In 1916, the year the Poor Richard Club put out its *Dictionary*, the city's mayor announced, at long last, that Philadelphia would build a subway and elevated system of some twelve lines in addition to the Market-Frankford Subway-Elevated Line already in service. By that time more than a dozen lines had long been operating in New York City. Philadelphia, mostly reliant on the stuffed-up streetcar, was already "slow," fragmented, nearsighted in comparison—and even then the Organization, the Republican political machine, barely got the Broad Street Subway finished in 1938.

The lack of a comprehensive subway system intensified Philadelphia's parochial nature in the twentieth century. And that parochialism, with its emphasis on family, row house, and neighborhood, contributes to the city's sense of accretion. In Philadelphia, regular people, in place, drive urban change through private, small-scale investment in their row houses and stores. Uniquely, among large cities, Philadelphia captures and accumulates minute layers of change, and many of those layers are hidden in the private realm. In Part 1 of this book, "City of Infinite Layers," we explore the city as palimpsest.

Once discovered, layers expand our understanding of the city. But some are invisible. One element of Philadelphia's "slowness" (or what Nathaniel Burt might call its "solemnness") is a product of the invisible layer of ground rents, a system of land conveyance used predominantly in Pennsylvania that allows nonwealthy people to acquire property.

Philadelphia was built on ground rents in the nineteenth century as tiny collectives known as building and loan associations supplied the capital for the construction of row houses. "The good order, comfort and prosperity of Philadelphia people are largely due to the beneficial and substantial work of these associations," Taylor notes in the *Dictionary*. This is why, he writes,

> a fashion exists in Philadelphia, amounting almost to a passion, for ownership. More houses are owned by their occupants than in any large city in the world; these number 125,000.

The "slow" city, then, is foremost a domestic city, with life centered on the home, family, neighborhood, and private social club (many more of these than public entertainments are listed in the *Dictionary*), a rich and intricate mosaic of urban life that is revealed when the observer peels back the layers of the Hidden City.

We have never thought it was an accident that an organization like Hidden City appeared in Philadelphia and not somewhere else. Boston and Charleston are a little too polished for their own good—and perhaps too small as well—to contain a sufficient supply of secrets. Indeed, during our first year publishing the *Hidden City Daily*, we thought we might run out of material once we had covered well-known-to-the-cognoscenti-yet-little-known-to-the-general-public places like the Divine Lorraine Hotel and the Metropolitan Opera House. Fortunately, six years on, our fears have proven unfounded. Philadelphia provides a seemingly endless supply of hidden layers.

Yet we can't accept, as perhaps Nathaniel Burt did, that the Hidden City was somehow preserved for our discovery by white elites rather than by tens or hundreds of thousands of immigrants (and second-, third-, and fourth-generation Americans), African Americans, and working-class people of every ethnic background. Those were the Philadelphians who adopted the row houses, churches and synagogues, societies, factories, and stores and kept them going, even during the collapse of the industrial economy in the 1970s and 1980s, when the city lost, net, 363,032 people. It is thanks to them and their struggle against the urban dissolution and fragmentation of the late twentieth century that the first Hidden City Festival in 2009 could present what felt like a lost world. They enabled *Hidden City Daily* writers to approach the blackened fossil of the city; they allowed its photographers to discover beneath the dust the brilliantly colorful though sometimes muted layers of the city that Frank Taylor revealed in his elaborately detailed sketches: real people and their aspirations overlapping with, and sometimes transforming, the vivid place they inhabit.

Among *Hidden City Daily* writers, a high school art teacher who goes by the pen name GroJLart peeks through the shadows of Philadelphia's streetscape, through boarded-up windows, through new additions, through

hidden doorways, to discover accreted layers of transformation and change. With each building he profiles, GroJLart starts with an inventor or builder and then adds layers of users who followed, each of whom adopted and then altered the building to suit her needs. A handsome neoclassical Bell telephone exchange becomes the Eckels College for Embalming, then an African American fraternal lodge, then a Mennonite church, and finally a community center. A service agency for female immigrants and industrial workers becomes a Young Women's Christian Association, which becomes a women's clothing manufacturer, then a cocktail bar and jazz joint called Little Johnny's. A late nineteenth-century bicycle club, the Quaker City Wheelmen, becomes a performance hall for German American singing societies, then an association of black barbers, and later an underground jazz club. Buildings that adapt to time and circumstance, and collect layers while doing so, characterize the Hidden City.

Over the years we have published dozens of articles, like those by GroJLart, that suggest ways of reading the city. Look with intent and discover clues to the many cities that existed—and still exist—layered within this one city. The clues appear all around: in the remnants of hand-painted signs, now "ghost signs," on the sides of buildings; in the remains of railroad trestles, bridges, tunnels, and stations; in pediments long buried under stucco; in Hebrew letters hidden by a signboard; in unsanctioned murals; in obsolete street names engraved in marble on a corner building. One hundred, two hundred years later, the names—Sassafras Street, Hepburn Street, Windsor Square—reveal traces of another day to the observant passerby.

Only recently has this kind of interpretation (certainly not *Poor Richard's Dictionary of Philadelphia* or *The Perennial Philadelphians*) acknowledged African Americans as protagonists in Philadelphia's urban process. This suggests that black life itself has been, for many historians and journalists of the nineteenth and twentieth centuries, a practically invisible layer of the city. As we begin to peel back the layers of the Hidden City in Part 1 of this book, we pay special attention to elements of the black experience as integral and powerful aspects of the accumulated composition of the city yesterday and today.

In Part 1, "City of Infinite Layers," and to a different degree in Part 2, "City of Living Ruins," we reveal the skeletal forms of the city, such as the row house and the inward arrangement of neighborhood life, the Catholic parish system, wills and frames of government, as well as missing or disguised layers like obsolete infrastructure. Some of these layers, and some of the ruins we explore, are, counterintuitively, highly conspicuous products of Gilded Age excess: civic monuments, polychromatic movie palaces, and colossal shopping bazaars. That they feel invisible today may be the result of a determined attempt by mid-twentieth-century civic leaders to identify Philadelphia as a city of the "colonial age" at the expense, particularly, of its sooty, corrupted industrial age. This perhaps misdirected

movement began in 1926, on the 150th anniversary of the Declaration of Independence. The Sesquicentennial World's Fair, an almost complete flop, re-created the city's original colonial-era High Street on fairgrounds in South Philadelphia—the Sesqui's only successful exhibit.

Writing in the early 1960s, Nathaniel Burt paid only scant attention to the civic energy that had been gathering for years, particularly among the hereditary elite, for restoring the city's eighteenth-century core: a movement so complex and nationally important that the architectural historian Lewis Mumford spent several successive *New Yorker* "Skyline" columns on it and *Time* featured it on the cover of its November 6, 1964, issue. Old Philadelphians followed the lead of reformist mayors Joseph Clark and Richardson Dilworth and took advantage of the federally funded Urban Renewal program crafted by city planner Edmund Bacon and began to purchase and restore eighteenth- and early nineteenth-century row houses in Society Hill, adjacent to the new Independence National Historical Park. At the same time, City officials enacted a historic preservation ordinance and created the pioneering Philadelphia Register of Historic Places. In 1965 the Secretary of the Interior announced national preservation standards and began to assemble a National Register of Historic Places. All this attention to legacy architecture was meant to help Americans, during the Cold War, identify with seminal events related to the birth of the nation. This identification provoked Philadelphia officials to clear away the agglomerated mess of Victorian, French-influenced, and Gilded Age overabundance, a process that was already under way. (In 1952 reformers got rid of the castle-like Broad Street Station, designed with dramatic muscularity by Frank Furness, Philadelphia's most gifted Gilded Age architect.) City planners and real estate developers set off to erase the tightly interwoven, almost airless commercial district around Independence Hall and created a vision for Independence National Historical Park, and they set off to eliminate from Society Hill all the immigrant-owned, soot-stained workshops and factories, stores and taverns—anything that reeked of moldering excess, poverty, or foreignness. The loss was swift and permanent, as was the gaining of a new "olde" streetscape. The worst loss was the demolition in 1960 of Furness's richly composed Provident Life and Trust Company at 4th and Chestnut Streets, replaced only much later, in the 1980s, by the quiet, buttoned-down Omni Hotel. The work of one of the first American architects of originality was removed so that we could see the English colonial streetscape more clearly.

Eliminating the particularly rambunctious layer of Philadelphia architecture that Furness, among others, invented had the effect of censoring time and distorting our inherited sense of the city. This was not confined to the middle of the past century. The process continues today just down the block from the Omni Hotel with the construction of the colonially derivative Museum of the American Revolution at 3rd and Chestnut Streets, the site of what had been the pioneering Jayne Building, which at 133 feet

high was the first American proto-skyscraper. The present-day visitor will look at the new museum—with its wooden windows, Federalist entryway, and cannons on the corner—and never realize that, as the preservationist Charles Peterson wrote in the *Journal of the Society of Architectural Historians* in 1950, "in the annals of the American skyscraper there was, perhaps, nothing more daring" than the Jayne Building. Nathaniel Burt was not tricked by the censorship because every building in Philadelphia, Federalist and French Second Empire alike, seemed to him filthy. But those of us who came later have been persuaded to align "colonial" (or "faux-colonial") with the Philadelphia shorthands "slow" and "solemn." By virtue of this reprogramming, we have been blinded to the still-vigorous evidence of the rich, colorful public commercial life that endured in various forms until the late twentieth century. It is partly because the deindustrialization of the 1970s and 1980s so effectively wiped out the commercial life of both neighborhood and downtown that this exuberant urbanism was lost as a cultural thread. Given that boosters, beginning in the 1950s, singularly promoted the colonial era in Philadelphia's history, perhaps it is not surprising that Philadelphians themselves should feel that their city had always been, in style, the staid and subdued "Quaker City."

THE MATERIAL OF RUINS

The loss of Gilded Age and industrial wealth, and the reconstruction of Philadelphia's identity as a "colonial" city, with the squandered substance of urban life so close by and yet oddly hard to see, created the material conditions of the Hidden City. In the singularly dark film *Twelve Monkeys* (1995), the director Terry Gilliam altered this perception. Gilliam employed large-scale ruins and other rundown city monuments—Richmond Generating Station, the Metropolitan Opera House, the Ridgway Library, City Hall, Memorial Hall, and Eastern State Penitentiary, several of which are discussed in this book—as the physical skeleton of a pre- and post-apocalyptic society. "A series of civilisations [sic] lived and died there [in Philadelphia]," Gilliam told *Sight and Sound Magazine* in 1996.

Writing in the early 1960s, Burt recalled what he felt was an apt description of Philadelphia: "like an old whore with her teeth kicked out." With the release of *Twelve Monkeys* more than a quarter-century of relentless economic punishment later, Philadelphia's ruined state—amplified by the camera, enhanced by set designers, and presented as the milieu of our society's demise—captured the national imagination. Gilliam followed a time-tested instinct. For centuries, the art historian Christopher Woodward affirms in his book-length essay *In Ruins* (2001), artists have portrayed ruins to symbolize human decay. And rarely had Philadelphia been brought to such flagrant life, as if Gilliam's script had put Burt's sorry

metaphor on steroids and set it loose. (In fact, in a pivotal scene, the film's female lead, played by Madeleine Stowe, a bright-eyed psychiatrist who seems undaunted by the unraveling decadence of the city, is mistaken for a prostitute by a deranged pimp who calls her a "coked-up whore" and tries to knock her teeth out.)

Living in a city selected as a dystopian metaphor by a film director, Philadelphians have had to grapple with the physical remains of other ages and other people, and their tastes and ideas—and their failures, as Luc Sante observes of Paris: "a tremendous expanse of time in compressed and vestigial form." In ruins, says Woodward, time collapses; we can visualize our own mortality: "When we contemplate ruins we contemplate our own future." But Woodward also suggests that grappling with ruins isn't just a religious or poetic experience (though it may be—a vast, expansive power station like Richmond Generating Station, which feels out-of-time, conveys a "still sorrow"), but at once a practical and an emotional challenge. It isn't an obvious process, he says: ruins might represent human decay, but they might also suggest wonder, fragility, sorrow, and inspiration. How we respond to a ruin or what we decide to do with it will depend on what it is and who built it and why they did, but also on the kind of city we wish to build in our own age. Thus we come to think of our urban ruins as live matter, and we come to see the Hidden City as a "City of Living Ruins."

At a practical level it seems that we prefer to restore our ruins if possible and put them back to use. Because of this preference, two decades on from the release of *Twelve Monkeys* the utter dystopia Gilliam portrays feels like a bit of history. The early twentieth-century Richmond Generating Station, with its massive turbines and neoclassical proportions, in its time one of the largest power plants in the world, continues to rot, but the Delaware Generating Station, another monumental 1920s-era power station along the Delaware River, is being restored as an event hall. The Metropolitan Opera House awaits a likely new life as a music venue. City Hall has undergone substantial architectural preservation. Memorial Hall (built as an art gallery for the Centennial World's Fair) and the Ridgway Library have been restored. Eastern State Penitentiary, now a serious museum addressing incarceration and punishment, exerts a special power as a stabilized ruin. Traditional restoration, like that pursued at City Hall; adaptive reuse, like the transformation of Memorial Hall into a children's museum, and the Ridgway Library into a creative and performing arts high school; and Eastern State Penitentiary, in its preserved suggestive dinge, all beg the urbanite to live in many periods all at once, to indulge in the carnival of "our ever-changing Philadelphia."

The restoration and reuse of these large-scale landmarks is only indicative of why we say the era of *Twelve Monkeys* is history. Billions of dollars in public and private capital have been invested in renovation, infrastructure, public space, transit, and new construction since the film's release, ending

Philadelphia's postindustrial decline and launching an era of growth and recalibration. Despite enduring poverty, social injustice, and deficits in education, the Philadelphia of 2016 engenders a pride of place far closer in spirit to the attitude of the members of the Poor Richard Club in 1916 than that of the Old Philadelphians of the 1960s.

Yet *Twelve Monkeys* confirmed what avant-garde city explorers were already discovering in the early 1990s: Philadelphia's massive ruined infrastructure—the Reading Viaduct, abandoned subway stations, endless factories, mills, and schools—held a melancholic weight and beauty. Here was time lost, in physical, tangible form, and it was, like the ancient ruins of Greece or Rome, picturesque. The film helped reignite an artistic attraction to ruins that began during the Middle Ages and now took the form of a new photographic movement whose followers ranged across American's Rust Belt, northern Europe, and even China and Japan. How heavenly beautiful was a snow-filled, sky-lit, abandoned railroad station, these photographers declared, and we itched to climb through windows and explore.

Ruins reflect a kind of human vulnerability, which may explain why for centuries artists particularly, as Woodward reveals, have been drawn to them. In the present day, with the aid of digital technology, photographers in the United States and around the world can produce purely objectifying images of urban ruins and disseminate them via the Internet. When the ruins are detached from context in this manner and transformed into surface image, they become "ruin porn," suitable for leering fantasy. Such photographs imagine, as pornography does, that the alluring object isn't connected to anyone's real life. For the city itself this disconnect is a kind of erasure, particularly for those who have to live with ruins, not as inspiration but rather as reminders that they have been left behind. This is the moral danger of ruin porn.

About the time *Twelve Monkeys* was released, the photographer Vincent Feldman exhibited his large-format photographs of the squandered civic architecture of Philadelphia (collected later in *City Abandoned*, 2014). In no sense ruin porn—for Feldman's approach is straight-up, and most of his images are of exteriors—here is the raw, undignified decline of dignified civic architecture and, more critically for Feldman, of the institutions those structures housed, touchstones of public life across the long nineteenth century. What strikes the viewer now, looking back at Feldman's photographs of the mid-1990s, is the degree to which Philadelphians have successfully reclaimed these buildings (though not, generally, the institutions) for our present day. Many were saved until the time was right by the administrative fiat of the Philadelphia Register of Historic Places, which protects buildings from demolition. Among the buildings featured in *City Abandoned*, more than a dozen and a half have been or are in the process of being reused:

Board of Education Building, restored for apartments
Divine Lorraine Hotel, restored for apartments
Eastern State Penitentiary, stabilized ruin, museum
Engine Company 13, restored as residence
Fairmount Water Works, restored as a museum
Hale Building, undergoing restoration for apartments
Memorial Hall, restored as Please Touch Museum
Metropolitan Hospital, restored for apartments
Metropolitan Opera House, undergoing stabilization as
 music venue
North Philadelphia Station, partially restored as Amtrak Station
 and shopping center
Nugent Home for Baptists, restored for senior-citizen
 apartments
Poe Public School, restored as a school
Reading Terminal Headhouse, restored as part of Pennsylvania
 Convention Center
Ridgway Library, restored as High School for the Creative
 and Performing Arts
Spring Garden School Number 1, undergoing restoration for
 affordable apartments for veterans
St. Anthony de Padua School, restored as a retirement facility
26th District Police Station, restored for apartments and retail
U.S. Naval Asylum, restored for apartments
Victory Building, restored for apartments
Warwick Apartments, likely to be restored as part of residential
 and retail development

If Feldman's obsession with the abandoned city sparked citywide awareness of these ruins, his photographs also persuaded many of us to get out, explore, and begin to see the city in ways Nathaniel Burt could not. This was a moment of enlightenment, an epiphany not unlike the one experienced in 1818 by the poet Percy Shelley upon seeing the ancient Roman ruins of the Baths of Caracalla. "Their exuberant and wild fecundity," writes Woodward, "promised the inevitable victory of Nature—a Nature which was fertile, democratic and free." And so we began to seek out ruins, not as evidence of decay but rather as raw material for our imaginative lives. Locating the ruins, getting inside them, and uncovering their history taught us to read the city, as ruins became part of our understanding of the life cycle of urban places. We learned to read buildings and infrastructure as a way to understand the configuration of neighborhoods and the hierarchy of building forms. The past seemed to bleed through to the present as we came to recognize that we were surrounded by living ruins, stimulating us to think about the future as well. These weren't ruins from

some distant past, we realized, but from an era recent enough to have been experienced by our parents and grandparents, who had themselves adopted the city and adapted it for their lives.

These experiences can produce an ecstatic feeling, something like scuba diving along a coral reef. Yet the longer we have been underwater, so to speak, after years of walking and climbing and writing and photographing the city, the more prosaic our understanding of the city has become. This is reflected in the language we use: for instance, describing buildings as "vacant," a neutral term, rather than "abandoned," a word freighted with emotion. Over time, we have come to see that what first inspired us to explore Philadelphia, the beauty we find in decay and the melancholy it evokes, are powerful feelings but a limited mode of experience. These emotions tend to elide the complicated roles of poverty and segregation in creating the material conditions that permit our poetic relationship to the city to flourish. Yet one awareness does not completely cancel out the other. Our personal repository of places merely grows larger and more mazelike, a mind map of the secret connections that, always adapting, animate the city and make it a site of endless wonder and sadness.

In Part 2, "City of Living Ruins," we explore the Philadelphia ruins that inspire us to pause and challenge our progressive notion of time. We take a close look at the process by which ruins become the raw material for shaping and reshaping the city, and we envision the social, cultural, political, and economic systems of past centuries, formed and then abandoned by those long gone, as a kind of invisible ruin that we inhabit today.

A WAY OF SEEING

To find evidence of the city dominated, in fact and form, by the Pennsylvania Railroad, the largest American corporation of the late nineteenth century, we have to search for it. To find the city of movie palaces, of giant power stations, we need to know how to look. To understand the scale of the industrial streetscape, we need to find ourselves inside the ruins that are so close at hand.

A love of discovering lost places, imagining what they were once like and, equally, what they might become, inspired the first Hidden City Festival. In the spring of 2009, several thousand people visited nine sites around the city that the general public normally would not be able to access. Only a few of the sites were abandoned in the traditional sense of being ruins left to decompose. But in each case the original, or prevailing, use had been distorted or diminished by time. Each site therefore revealed a lost era or a lost community. The spaces themselves constituted the Hidden City.

Hidden City Festival founder Thaddeus Squire, a student of music who had trained to be an orchestral conductor as a Fulbright scholar in

Plate I.3 (following spread)
Our Mother of Sorrows Roman Catholic
Church, stairway to the steeple,
West Philadelphia, 2015

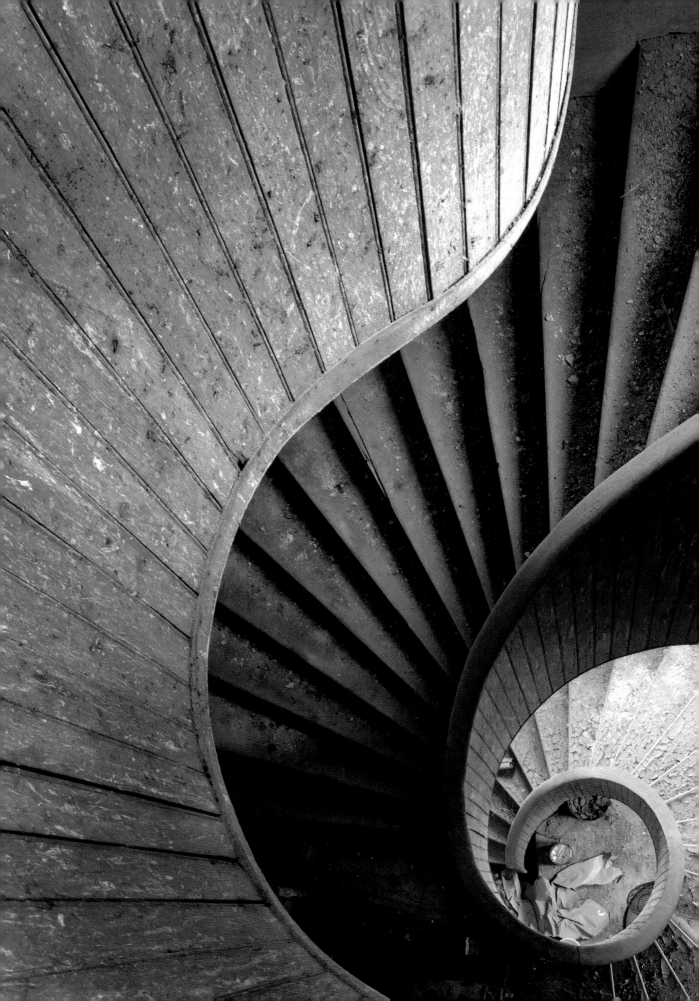

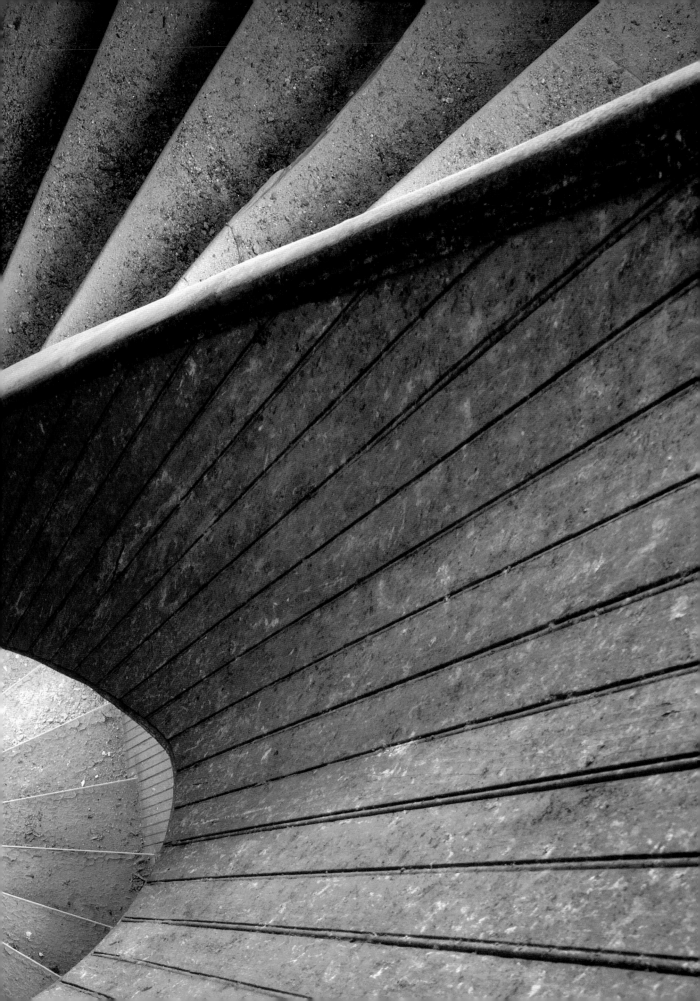

Germany, selected an artistic project for each site. The artists' interpretive installations and performances would animate the festival spaces and draw the public in to observe the grandeur of the past, meditate on loss, and imagine possible futures. The point of this act of exploration and discovery was to broaden and deepen participants' experience of the city. This newly acquired territory, external and also intrinsic to quotidian Philadelphia, suggests the power of the Hidden City. It also suggests that in this context hiddenness has a dual nature. In all cities there are hidden elements (and to a certain degree the real life of a city always happens behind the façade). Cities are full of things hidden by poverty, wealth, locked doors, the passage of time, obsolescence, and adaptation. The mechanical works are hidden underground. Philadelphia possesses hidden elements that await the intrepid explorer, and it also possesses a propensity to keep these things hidden.

Joseph E. B. Elliott had been photographing landmark architectural spaces for the Historic American Buildings Survey for the better part of a decade when Squire commissioned him to document the Hidden City sites before and during the festival. Elliott's earlier photographs of the Divine Lorraine Hotel and Disston Saw Works appear in this book, along with images of Hidden City Festival sites like Girard College, the German Society, the Metropolitan Opera House, the Royal Theater, and Shiloh Baptist Church.

A little more than two years after the Hidden City Festival, we—journalist Peter Woodall, who had served as a festival volunteer, and writer Nathaniel Popkin, a longtime observer of the city—launched a web magazine, the *Hidden City Daily*. Our desire was to replicate the drama of the festival through narrative journalism and photography. Journalism, which exists to reveal hidden truth, would stretch the project into the visceral now of a city experiencing rapid change. As Philadelphia entered a new period of growth and transformation, the *Hidden City Daily* would provide rich context and critical analysis. Not quite content being passive urban observers, we imagined that the interrogation would yield a way of seeing and reading the city itself.

Along the way, about one hundred passionate and talented writers and photographers joined us, most notably our co-editors: Bradley Maule, founder of the website PhillySkyline.com, and Michael Bixler, a journalist and a longtime administrator at Eastern State Penitentiary. Their contributions have multiplied our capacity to dig and discover. Joseph Elliott returned to the Hidden City team in 2013 as the official photographer of the second Hidden City Festival; he photographed Germantown Town Hall, Globe Dye Works, Hawthorne Hall, the John Grass Wood Turning Company, and Shivtei Yeshuron Synagogue. This book is a product of our longtime collaboration.

Although Elliott's photographs from the two Hidden City Festivals make up a sizable portion of the photographs here, much more of the book

emerges from his own photographic practice and the connection he feels to Philadelphia's long nineteenth century. His photographs often reveal an elemental beauty of architectural form, as if to suggest that the Hidden City is, in essence, pure. Elliott's lens on the interior stair to one of the two bell towers of Our Mother of Sorrows (Plate I.3), a Catholic church on North 48th Street in West Philadelphia, confirms this belief. To encounter the Hidden City, we have to look behind the façade. The camera becomes an X-ray, revealing the city's skeletal form.

In this sense, Elliott's photographs of a West Philadelphia sewer outlet pipe, with ghosted Philadelphia Water Department workers reinforcing the lost and distant nature of the world being unveiled (cover photo, Plate 1.28), and of a Water Department filtration chamber (Plate I.4), reveal a skeleton of engineered beauty, a city that is a machine. In both of these infrastructure installations we see two elemental and yet typically inelegant materials—brick and concrete—pressed into delicate service. More than any other, brick is the elemental material of Philadelphia, in part because Philadelphians have often tended to see a moral dimension in built form generally, and especially in brick's earnest simplicity and traditional connection to England.

The early American physician Charles Caldwell believed that environmental qualities engendered epidemic diseases like yellow fever, and he wondered, in an 1802 treatise, if Philadelphia shouldn't abandon English-style architecture and its endemic brick. Given that its climate was far more tropical than England's, cooling materials like stone and the thick walls, minor fenestration, and shaded courtyards of Spanish and Moorish building forms would be more appropriate. But few listened to Caldwell, perhaps because major business interests had invested in brickyards. Even in 1802 it was too late to question brick. Once it was the singular identifying material, it had to remain so—otherwise the city would be lying to itself. And so brick was used for everything, including delicate vaulted ceilings, archway bridges, the giant culverts that made up Philadelphia's pioneering water and sewer system, and even as the base material of the French Second Empire–style City Hall, a building of luminous white stone. During the thirty years of construction (1871–1901), masons installed some eighty-eight million bricks in the vaults of City Hall, as Elliott's photograph reveals, and in the walls and tower (Plate I.5). That photograph, like Elliott's images of the snail-shaped staircase in the Mother of Sorrows tower, the water filtration chamber, and the West Philadelphia sewer culvert, suggests the enduring power of the craftsmanship of Philadelphia's long nineteenth century.

Elliott's photographs reframe the view to enable the reader to see farther, deeper, and more clearly. But they also suggest that the Hidden City is not a singular place of skeletal simplicity. Rather, it is many thousands of places layered one atop the other, intersecting in complex ways. Look at his exterior view of the Globe Dye Works building on Torresdale Avenue

Plate I.4 (following spread)
Former water filtration chamber,
Northwest Philadelphia, 2016

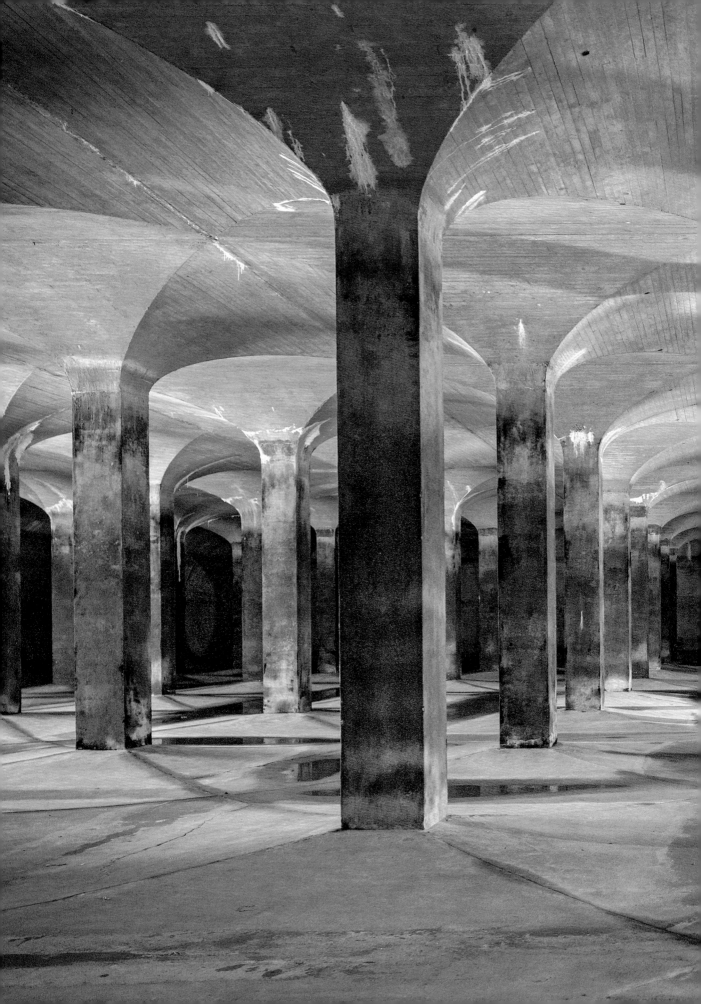

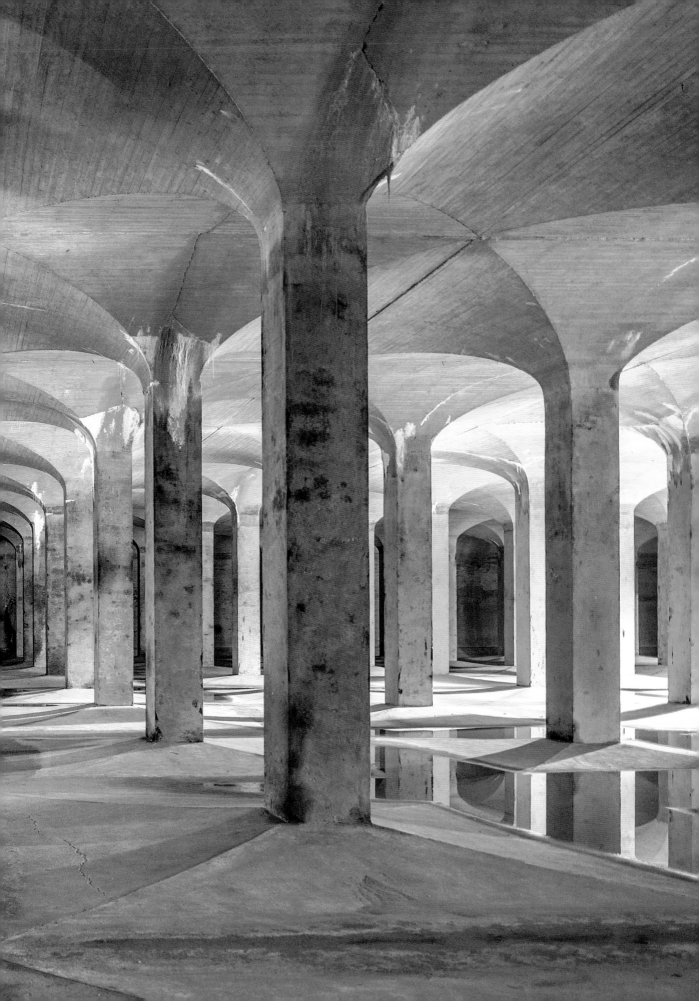

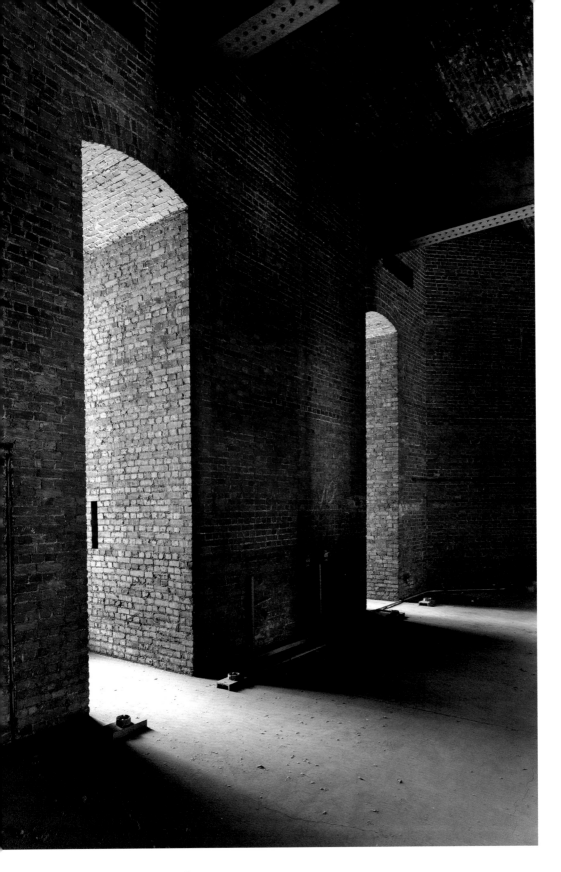

Plate I.5
City Hall, interior of the tower,
2016

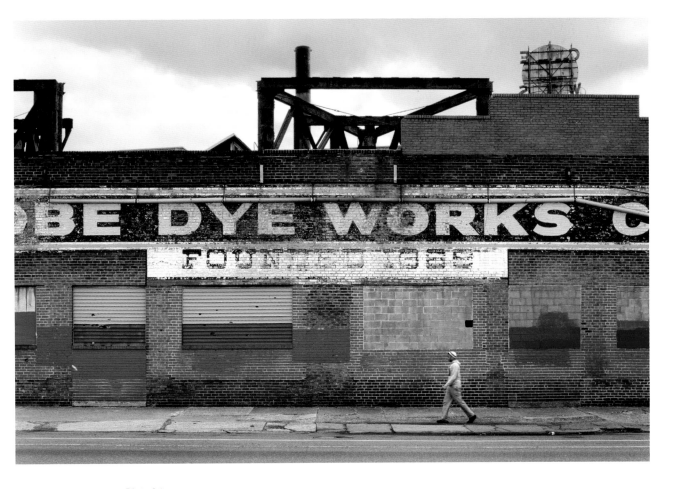

Plate I.6
Globe Dye Works, exterior
elevation, Frankford, 2013 (HCF)

Plate I.7
Germantown Town Hall, view from
the portico, Germantown, 2013
(HCF)

in Frankford (Plate I.6). A man in the present-day city walks past the long exterior wall of a factory built in stages starting in 1867. The complex composition of the streetscape makes the layers plain: windows cinder-blocked and boarded-up as eras changed, red and green paint used to cover over graffiti, the various kinds of bricks installed over many decades, the hand-painted and well-faded "Founded 1869" on a steel skeleton peeking almost mysteriously above the roof line, and the iconic "Globe Dye Works" in neon letters over the circular globe, installed in the twentieth century, which faces away from the camera and toward the distant Atlantic Ocean and the world beyond. In each of these layers we sense a different hand, a different intent. Each hand reveals a secret of the Hidden City.

And yet the composition also protects the secrets. The cinder-blocked exterior and faded sign obscure rather than suggest the new life inside the building. So much is, indeed, in disguise. The cinder blocks suggest that the mill is vacant. But it is possible, by really observing the city, to know that scores of old factories with cinder-blocked windows that look abandoned are still in use. This one was until it was adapted for reuse for art production and light manufacturing in 2008. Dozens of artists and craftspeople have transformed the sprawling mill into a contemporary place of production.

Similarly, Elliott's disconcerting view from the portico of the vacant Germantown Town Hall (Plate I.7) directs the viewer's attention to the layers of pretension and defensiveness that have followed, one upon the other, at the corner of Germantown Avenue and Haines Streets (the green street sign is just barely visible in the upper right). The viewer is forced to contemplate the corner through the chain-link fence that City workers installed to keep vandals away from the inviting staircase of the portico. Through this screen we see the building's ornate neoclassical detailing, the crumbling concrete of the portico floor, the handsome wrought-iron fence and bright green lawn of Germantown High School, now closed, the meticulous cobblestone and trolley-track installation for a streetcar that no longer runs, and, catty-corner to the Town Hall, the cool colors of a mural portraying black women in local history. Elliott's lens tells us about a city that evolves, characteristically, by accretion. New insertions into the streetscape almost ritualistically acknowledge the old.

In this book we invite readers to seek the Hidden City. We argue that the act brings them into direct contact with not only the city that is, but the city that was. The layers are the product of the past, of others' ideas and adaptations. From a material standpoint we can see and touch what others, long before us, have done and made. This encounter interrupts the dominant progressive nature of time, the incessant forward motion of contemporary life. It begs us to think of the latent past as a kind of frontier for exploration. In Philadelphia, even more than in other American cities, this frontier is, to those who know how to look, at once an unmarked victim of neglect, a legible tableau of urban history, and the raw material of the future.

City of Infinite Layers

Molasses

Vinegar

Chests of Black

Bbls. Flour

Mackerel

doz. Eggs

Scrubbing B

1½ " Sweeping

1 " Brooms

Macy's in Center City Philadelphia is a portrait of the old-fashioned brick and mortar department store. Once it was Wanamaker's, greatest of Philadelphia emporiums from the golden age of retail, brainchild of Philadelphia merchant John Wanamaker. Nowadays it suffers from a creeping shabbiness, with chipping paint and worn-out carpets. Yet, as in so many places in Philadelphia, what was built more than a hundred years ago lives on in unlikely and unexpected ways.

On the second floor, in Women's Apparel, an organ console sits on a platform overlooking the store's central courtyard. Few shoppers seem to notice the ten-foot-tall mahogany structure and railing, hidden in plain sight. The woodwork, once painted white and therefore camouflaged among the white fluted columns of the Renaissance Revival interior, was restored in 2015. Here it is on the sales floor as if it were an embassy from a foreign land. Climb inside and find yourself confronted with an elaborate contrivance of six ivory keyboards, hundreds of colored tabs signifying various instruments and sounds, and forty-two foot pedals.

A few feet away, beyond a display of discounted activewear and past racks of designer pants, stands a heavy wooden door designed in a neoclassical style to resemble the entrance to a Greek temple. This, indeed, is the passageway to the foreign land, a world within a world. The wooden plank floor leads to a small workshop that, with its burnished wooden hues, tools and gauges, blueprints, framed newspaper articles, and portraits of old men, looks like a Hollywood-idealized vision of a foreman's office in a family-owned mill from, say, 1916. Yet the wooden walls aren't walls at all. They are pipes, some ten inches wide, the first suggestion of what lies beyond. After going through a labyrinth of catwalks, ladders, and planks, the visitor reaches dozens of Escheresque cities of organ pipes, some wooden, others made of galvanized metal, a spotted alloy of tin and lead that resembles the skin of a giraffe. Everywhere are clocks, gauges, and gadgets and more planks that lead deeper into this cosmic machine.

Bringing this gigantic organ to Philadelphia was probably the idea of John Wanamaker's son Rodman, who managed the Wanamaker store in Paris and wanted the Philadelphia flagship to present high culture to a mass audience. The organ had been built for the 1904 St. Louis World's Fair and then sold to Kansas City, Missouri. When plans to install it in Kansas City's civic center fell through, the Wanamakers had the organ shipped in a thirteen-car train to Philadelphia and integrated it into the plans for their extravagant new store, which was dedicated on June 22, 1911. At twelve stories, spanning an entire city block and covering two million square feet,

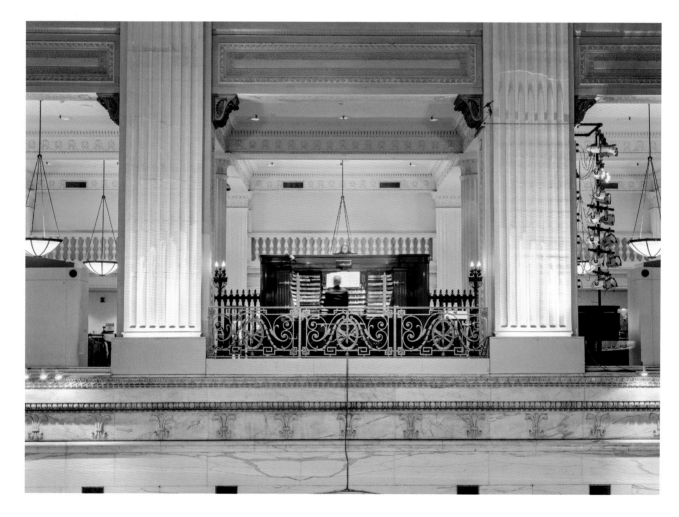

Plate 1.1
Wanamaker Organ, console from
a distance, 2016

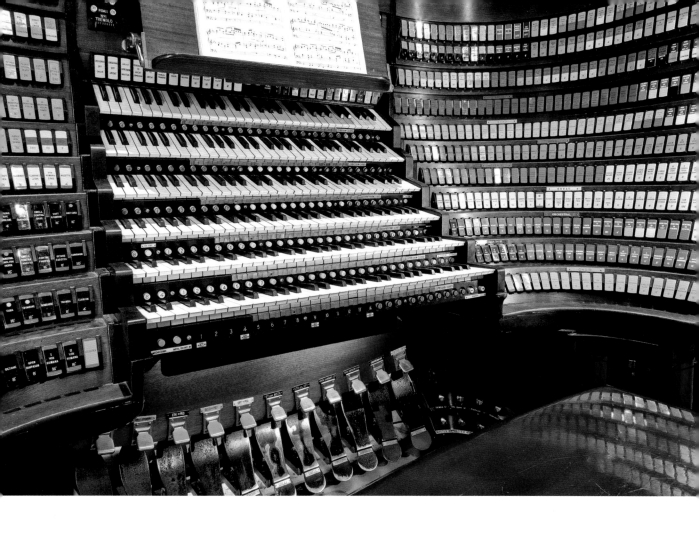

Plate 1.2
Wanamaker Organ, console, 2016

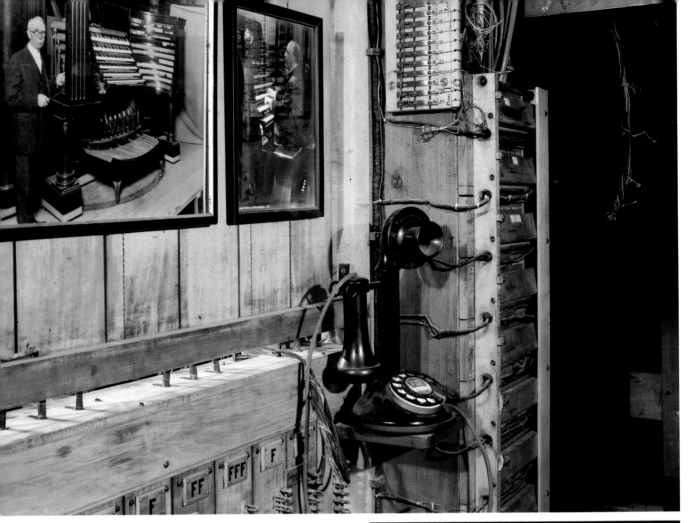

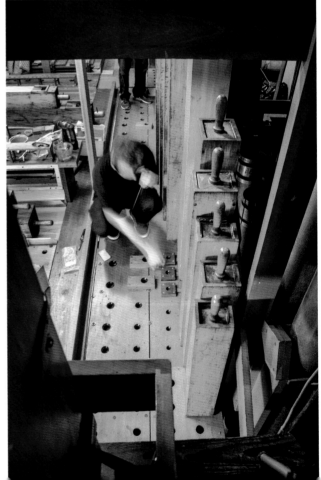

Plate 1.3
Wanamaker Organ, phone to the console, 2016

Plate 1.4
Wanamaker Organ, making repairs, 2016

the new Wanamaker store was one of the largest in the world. Its pipe organ, uncontested as the world's largest, sat among other enormous displays of Philadelphia's industrial wealth and Gilded Age progress. Across the street, the 548-foot tower of Philadelphia's City Hall was designed to be the world's tallest, although the Eiffel Tower surpassed it before it was complete. And opposite City Hall on the west side sat the largest railroad terminal in the world: the Broad Street Station of the Pennsylvania Railroad.

Exactly 10,059 pipes produced the orchestral sound of the new Wanamaker store, but they weren't sufficient to fill the immense seven-story internal courtyard, called the Grand Court. Expanding the instrument was the only practical solution, so Rodman Wanamaker retained William Fleming, the organ's chief builder, as an employee; for the next several years Fleming oversaw an organ factory that operated in the store's twelfth-floor attic. There, workers constructed wooden pipes, and designers put in orders for pipes made from customized metal as the organ grew to more than 17,000 pipes in 1917. By 1932, when the factory closed, the Wanamaker Organ had nearly tripled in size, to 28,628 pipes.

The Wanamaker Organ is a folly. Even if the Wanamakers believed that the organ would increase sales (and they always denied this), they might have chosen any number of other, less costly strategies. That such a colossus endures in our era, with its emphasis on efficiency, creates a sense of wonder.

The Wanamaker's chain was sold several times in the 1980s, and finally ceased to exist after being purchased by the May department store company. When May officials turned the store into a Macy's, they retained a small team of full-time craftsmen to maintain the organ, a minor miracle in the downsizing retail industry. A third-floor shop, in the former men's department, continues to manufacture small parts such as the wooden bellows used as valves. On the same floor, intact but hidden, are Wanamaker's original Egyptian- and Greek-themed auditoriums (the Egyptian Hall contained a piano showroom). In Macy's present condition, shrunk to barely three stories, it is nearly impossible to discern that the store once housed the John Wanamaker Commercial Institute, the American University of Trade and Applied Commerce, classrooms for workers, a post office, a telegraph office, a medical suite, three restaurants for shoppers (including the fourteen-hundred-seat Crystal Tea Room, now a banquet hall), a radio station, and, in the home furnishings department, a model house. Indeed, a children's monorail once traversed the toy, camera, and piano and organ departments. An in-house bookstore offered dime-store novels and rare books; advertisements claimed that it offered hundreds of foreign titles "almost as soon as they are published abroad."

John Wanamaker created this world inside his store as a kind of dream of the perfect city. A religious man, he imagined that the dream city had an "inner life" and each year produced a guidebook to the store's many facets. When the organ is played—forty-five-minute recitals eleven times

Plate 1.5 (following spread)
Wanamaker Organ,
String Chamber, 2016

37

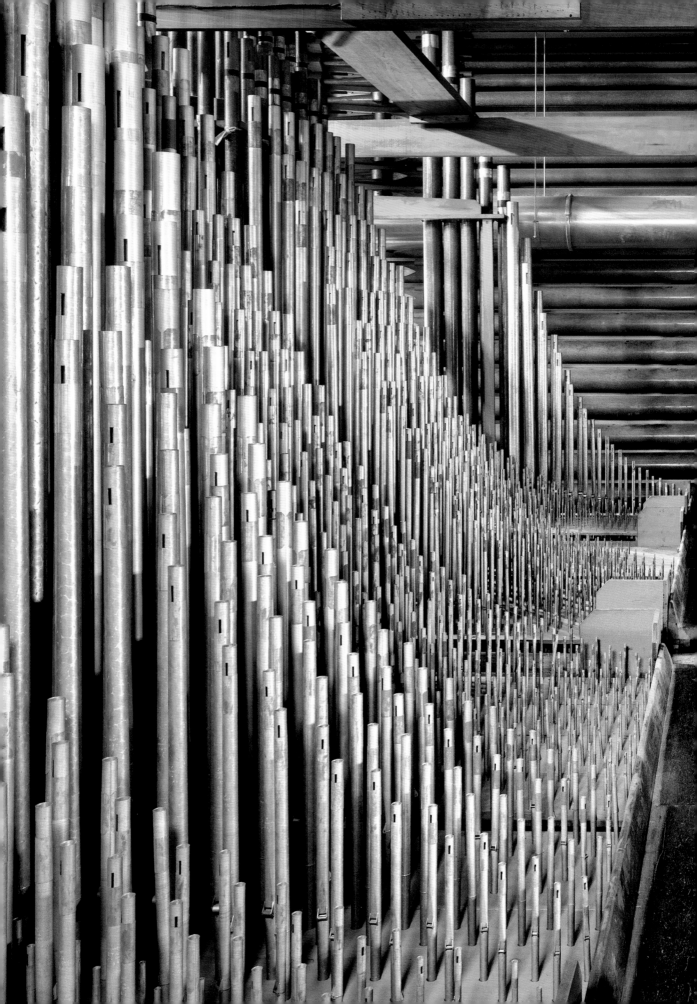

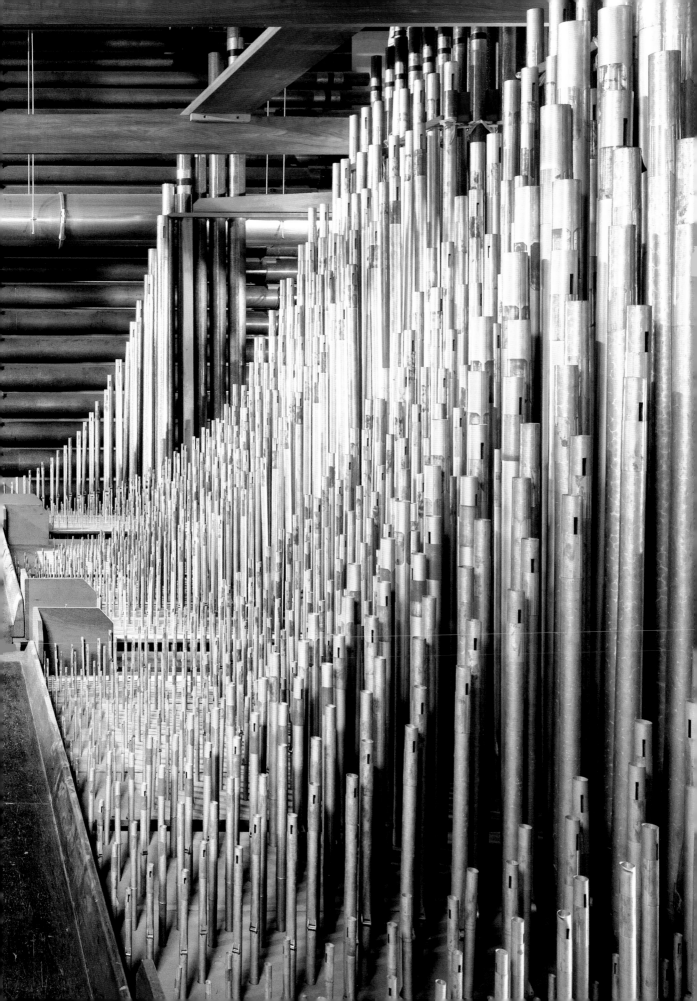

a week—it produces the ghost sound of Wanamaker's lost world. The recitals remind us that deep inside the building is a magical place that nearly everyone misses: crowds of pedestrians on Chestnut Street outside, the shoppers on the remaining sales floors, the thousands of office workers at their desks in the floors above. In an era when it appears that the entire planet has already been explored by humans, it is remarkable to discover the worlds concealed in Philadelphia's many layers.

Although the Wanamaker flagship store has survived as a shell of its past self, its future as a department store is precarious. Under extreme pressure from online competitors, Macy's is downsizing its chain of brick and mortar stores. The building is a National Historic Landmark and protected from exterior alteration and demolition by virtue of being listed on the Philadelphia Register of Historic Places. These designations do not extend to the organ or to the engraved signature of John Wanamaker in the entranceway, yet even if one day someone turns the department store into a hotel, we will not lose the entirety of this layer of the city's narrative.

But the vast majority of public commercial buildings in Philadelphia have never been listed on the Philadelphia Register of Historic Places and are therefore not protected from intensive alteration or demolition. In the 1970s and 1980s, the last traces of World War II industrial expansion went fallow, and industry-protective public policy gave way. Hundreds of factories, mills, and workshops, dozens of schools, churches, movie theaters, five-and-dimes, department stores, drug stores, men's shops, farmers markets, social halls, bakeries, cooperatives, book dealers, lunch counters, fire halls, banks, and building and loan associations—the threads of the dense fabric of neighborhood commercial life that Frank Taylor observed in his sketches and lithographs—were obliterated or destroyed. The redevelopment of Philadelphia's historic core in the 1960s had sought to remove evidence of the Gilded Age, seeing its outsized ambition and excessive architecture as somehow not properly representative of the modest American revolutionary character. The population collapse of the 1970s and 1980s effected another sleight of hand, erasing the evidence of neighborhood density (and even building height) and colorful, boisterous, animated public commercial life. The principal shopping and entertainment streets, like North Broad, Front Street, Fifth Street, and Germantown, Baltimore, Allegheny, Frankford, Girard, Erie, Cecil B. Moore (Columbia), Point Breeze, and Snyder Avenues, were stripped of neon, hucksters, vendors, and jazz sounds. From the perspective of 1995, the year *Twelve Monkeys* was released, the city's form appeared binary, not dynamic. Downtown was functioning though saggy, as the former Wanamaker's (at this stage an outpost of the Washington, D.C., chain Hecht's) became the only survivor of the five traditional department stores east of City Hall. Meanwhile the low-slung "residential" neighborhoods were impoverished in every sense, lacking money and things to do.

With all these pages torn out, the urban observer falls back on the sheer size of the book. The long nineteenth century produced far more material culture than could be eliminated so quickly, even by something as ominous as "deindustrialization." In 2012 *Hidden City Daily* contributing writer Rachel Hildebrandt began to piece together layers of this lost world so that we might read them more easily. She set out first to define the architectural typology of a chain of five-and-dime stores owned by the S. S. Kresge Company on neighborhood shopping streets. Founded in 1897 by Sebastian Spering Kresge, the national chain had about twenty of these achingly familiar stores in Philadelphia; many lasted into the 1970s after the chain rebranded itself and expanded as Kmart. Hildebrandt uncovered eight still-functioning former Kresge buildings around the city in a range of architectural styles from neoclassical to art deco. Most of them were in use as retail stores. It is easy to revisit the world Kresge's inhabited. Frank Taylor's views take us partway there; photographs collected in the City Archives or the Athenaeum of Philadelphia or Temple University Libraries' Urban Archives remind us of the thick, intricate nature of the commercial street, lurid and chaotic as it could be. Connected to the whole of the city by streetcar line and subway and elevated stops, the commercial avenue was open to outsiders and at the same time a place of neighborhood familiarity. Children inhabited this world to a striking degree, as an extension of house and block, a doorway to adulthood. For everyone, though—machine operator, stenographer, teenage couple on a date, ten-year-old boys out to get away with something—the movie house was the avenue's defining place, and often there were two or three on a single block.

The immigrant Siegmund Lubin, a pioneer of cinema, was the first American film studio boss. Lubin assembled a large studio complex, which he called Lubinville, in the North Philadelphia neighborhood of Swampoodle, near 20th Street and Lehigh Avenue. He opened his "Cineograph," the first movie house in the United States, in 1899, adjacent to the University of Pennsylvania, for the National Export Exposition at Philadelphia's Commercial Museum (torn down in 2004). One of the short (silent) films featured at Lubin's Cineograph was *A Trip to the Moon*, similar in concept to *Le Voyage dans la Lune*, the pivotal 1902 film by the early French filmmaker Georges Méliès. Indeed, the movie house peddled fantasy as its most alluring commodity from the very start.

The early movies-only theaters were known as nickelodeons. Usually set up in converted storefronts, these small, simple theaters charged five cents for admission and flourished from about 1905 to 1915. Almost all of the larger, more ornate theaters built before 1915, including the Empire (1891), the Fairyland (1909), the Victoria (1909), and the Orpheum (1912), were primarily vaudeville houses or playhouses (or both) that showed silent movies as part of a larger show. Beginning around 1915, film studio bosses, theater magnates, and serial entrepreneurs opened downtown and

neighborhood movie houses, fantasy showplaces meant to thrill and impress: the Alhambra (1918), the Royal (1920), the New Olympia (1921), the Imperial (1923), the Diamond (1923), the Bijou (1924), the Hippodrome (1925), the Midway (1932), and the Apollo (1933). They built more than four hundred of them, some works of such exuberance that, at night, a neighborhood intersection like Kensington and Allegheny Avenues would be bathed in polychromatic light.

Inside, past the garish foyer with its murals and trompe l'oeils, plaster carvings and rainbow fanlights, the screen itself projected a world of skin, seduction, and violence. The moralists' self-righteous indignation was unbounded. Philadelphia already had two centuries of moralism behind it, starting with the Quakers, who believed music was sinful. In 1934 Cardinal Dennis Dougherty, the head of the Catholic Church in Philadelphia, decreed movie going to be a sin and outlawed it among the faithful. A large proportion of Catholic Philadelphians, perhaps as large as 50 percent, took the decree seriously, and movie attendance, already down because of the Depression, dropped even more. (Two months after the decree, Philadelphia's Franklin Institute presented the first public demonstration of television in the country, which drew round-the-block crowds for two weeks straight.) The decline speeded the end of the dazzling Mastbaum, at 20th and Market Streets, designed by the renowned architectural firm Hoffman and Hernon, which also produced the Boyd Theater, an art deco masterpiece, a block away. With five sprawling lobbies, all decorated with Czechoslovakian crystal chandeliers, the Mastbaum was like a Greek temple on steroids. Though it survived a closing in 1934 and an interlude as a vaudeville house, the Mastbaum was demolished by 1958.

The Mastbaum, the Earle, the Fox—indeed, all of Center City's movie palaces, except for the Boyd, which was mostly demolished in 2015— were torn down between the 1950s and the 1990s. Yet around the city 135 theaters remain standing (including a few older and smaller theater buildings downtown), most of them in use as churches, grocery stores, live theaters, and warehouses. Examining architectural typologies, locations, and built form, Hildebrandt told *Hidden City Daily* readers "How to Spot a Theater," another way to read the layers of the city from the street. From the interior, too: spot an art deco mural at the Hollywood, otherwise damaged by fire; the dazzling auditorium of the Felton, for years a nightclub and now a church; the balcony of the Girard, peeking through the ceiling near the meat counter of the Fine Fare supermarket on Girard Avenue; the flyhouse, proscenium, side decorative balconies, and the blue sky ceiling and stars of the Circle on Frankford Avenue, concealed behind the back cinder-block wall of a sneaker shop; the art deco decoration and stained glass of the Ambassador on Baltimore Avenue, now a print shop.

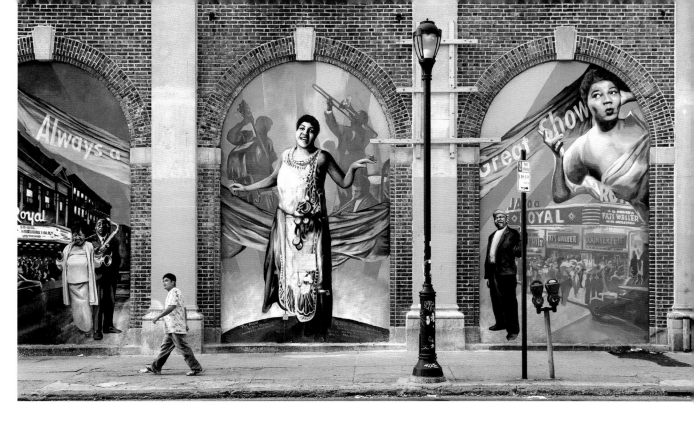

Plate 1.6
Royal Theater, front elevation,
South Philadelphia, 2009
(HCF)

———

43

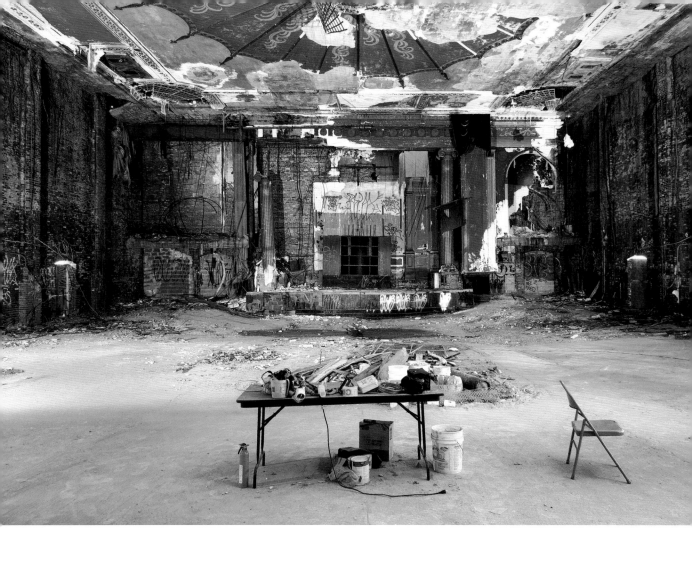

Plate 1.7
Royal Theater, looking toward
the stage, 2009 (HCF)

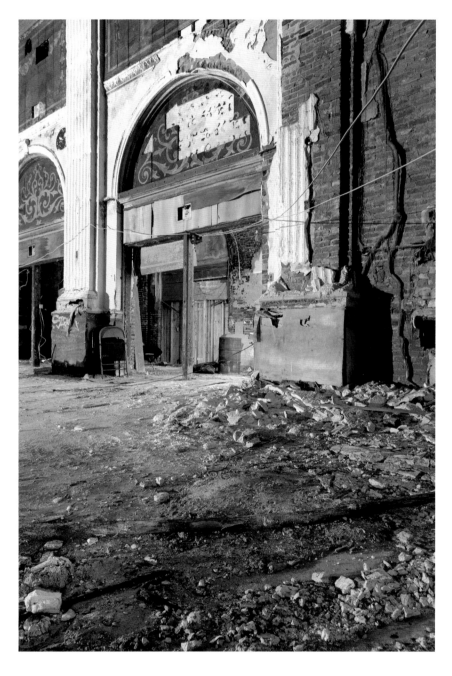

Plate 1.8
Royal Theater, back wall,
2009 (HCF)

The first Hidden City Festival, in 2009, invited the public inside the Royal Theater on South Street a block west of Broad. The Royal's interior was already in a ruined state, and it has deteriorated since then. This is one building that doesn't conceal its original purpose, however. The Royal, which advertised itself as "America's Finest Colored Photoplay House," was part of an elaborate black communal enterprise that was a necessary and powerful response to legal segregation and institutional racism, a layer of Philadelphia life mostly concealed by the indifference of white journalists and politicians. Black patrons were often unwelcome at other movie houses; the balconies, guarded by gangs of white teens, could be hostile territory. In the late 1920s the Royal screened films made by the Colored Pictures Film Corporation, a short-lived Philadelphia-based startup that produced its own titles with black artists, technicians, and actors. The Royal's managers helped organize the Negro Motion Picture Operators Union. Eric Okdeh's 2005 mural on the building's façade—showing Fats Waller and Bessie Smith (who lived around the corner from the theater), along with crowds under the marquee—signals the Royal's place in the black life of Philadelphia from 1920, when the movie house opened, to the 1960s. Okdeh's painting, sponsored by Philadelphia's Mural Arts Program, conveys the exuberance and sheer scale of the historic black neighborhood around South Street, the oldest continuously inhabited African American neighborhood in the United States.

For most of the city's four hundred years—in fact, until quite recently—the stories of black life in Philadelphia have been missing from media reports and historical accounts. The German immigrant artist John Lewis Krimmel, who lived in Philadelphia from 1810 until his accidental death (by drowning) in 1821, regularly included black people in his street scenes and often contrasted white affluence with black poverty. He showed black men working as oyster vendors, sawyers, and chimney sweeps, and African Americans worshipping at the oldest black church in America, Mother Bethel. He portrayed the church's pastor, the civil rights leader Richard Allen, standing on the corner of 2nd and Church Streets. In the next generation, the journalist, author, and early civil rights activist George Lippard wrote black characters, some heroic, into his gothic novels. But when the great black intellectual, political leader, athlete, and soldier Octavius V. Catto was assassinated on Election Day in 1871, the papers barely mentioned it. Before W.E.B. DuBois, a black scholar, wrote *The Philadelphia Negro* in 1899, no white civic or intellectual leader had given Philadelphia's African American community serious, sustained attention. Only after a deadly building collapse in 1936 two blocks from the Royal Theater did Philadelphia's Republican political machine—in power almost without interruption since the 1871 municipal election—commit resources to improve conditions in black neighborhoods.

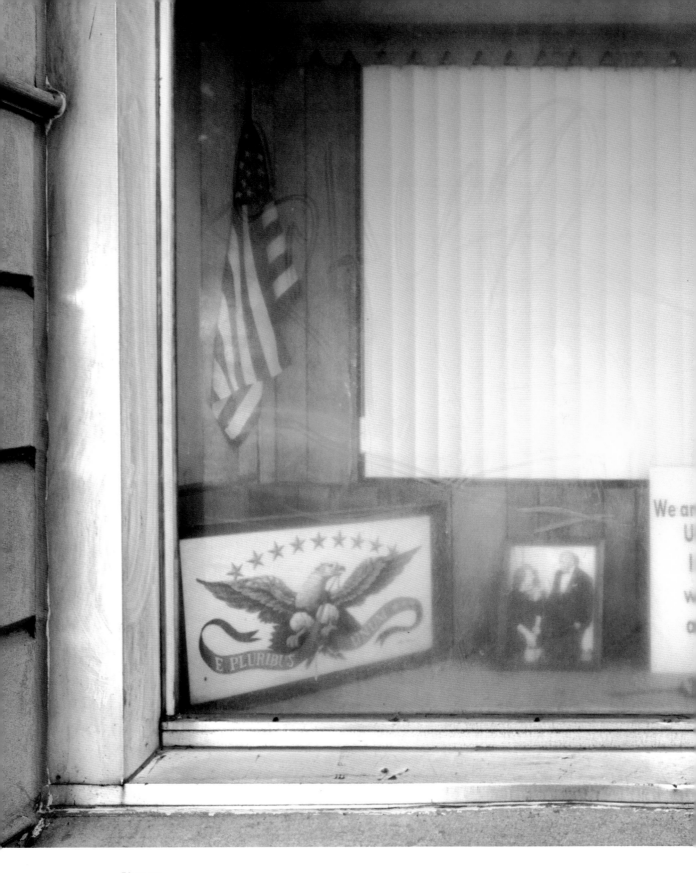

Plate 1.9
Circle Mission Bible Institute,
South Broad Street, 2016

A few years later, in 1942, a black man who called himself the Reverend Major Jealous Divine, or God, arrived in Philadelphia from Harlem in New York City. Father Divine was the head of the Peace Mission Movement, an ascetic Christian sect. Not believing in heaven, followers of Father Divine sought paradise on earth. Divine was a capitalist and built a network of hotels and cleaning businesses run on a cash-only basis. He was also a deliberately provocative civil rights leader who fought for integration. By purchasing and preserving some of Philadelphia's most elaborate Gilded Age mansions, estates, and hotels, Divine could house large groups of followers relatively cheaply while reifying the material paradise they would conserve forever. This effort preserved a layer of Philadelphia's fabric that would otherwise have disintegrated. Moreover, the conspicuousness of the Peace Mission's holdings made this particular sliver of African American life abundantly visible.

Nowadays, it is easy to miss the framed portraits of Father and Mother Divine exhibited in the window of the Circle Mission Bible Institute. The faded photographs sit behind the semiopaque window of an old storefront, a mauve-painted former mansion built in 1897 at South Broad and Catherine Streets, just a few blocks from the Royal Theater. The Circle Mission was the first building Father Divine purchased when he arrived in Philadelphia, and now it is one of the last still owned by his Peace Mission. Like John Wanamaker and Siegmund Lubin, Father Divine created an elaborate parallel world in Philadelphia, which he underwrote with proceeds from the cleaning business, hotels (most notably the Divine Lorraine on North Broad Street), and cafeterias, all staffed by his followers. The badly faded portraits of Mother and Father Divine are signposts of this layer of the Hidden City. Though believed immortal, Father Divine died in 1965, and Mother Divine in early 2017. The Peace Mission Movement has shrunk almost to nothing. This once-shining world is now barely perceptible.

For years elderly acolytes, most of them women who made a vow of chastity and allegiance to Father Divine, have carried on the work of his idiosyncratic ministry under the direction of Mother Divine. These white and black women, drawn to Father Divine's message of racial harmony, selflessness, and material abundance, have taken names like Faith, Truth, and Joy. A few live at the Circle Mission in South Philadelphia or at the Unity Mission Church, Home and Training School, in North Philadelphia. Others live at Woodmont in the suburb of Gladwyne, a French-style chateau built by the steel magnate Alan Wood Jr. in 1894 and purchased by Father Divine with cash in 1953.

Every day the remaining members of the Peace Mission church hold a "holy communion banquet," a eucharistic meal. Leonard Norman Primiano, a professor of Religious Studies at Cabrini University, in a scholarly anthology entitled *Religion, Food, and Eating in North America* (2014), calls it an "intense demonstration of reverence and devotion … [a] celebration and

Plate 1.10 (opposite)
Unity Mission Church, Home and
Training School, exterior, North
16th Street, 2002 (HABS)

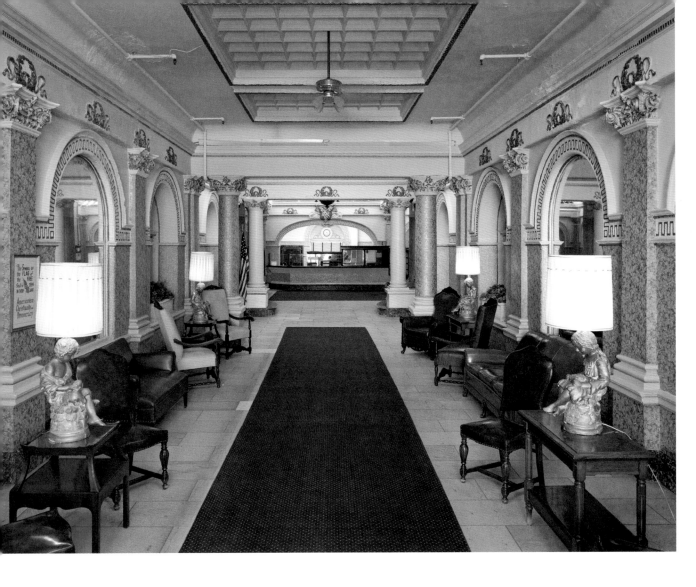

Plate 1.11
Divine Lorraine Hotel, lobby,
North Broad Street, 2002 (HABS)

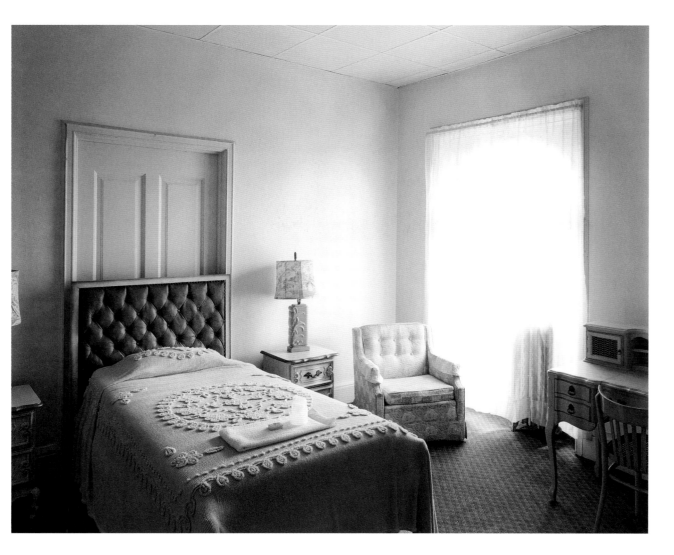

Plate 1.12
Divine Lorraine Hotel, typical room,
2002 (HABS)

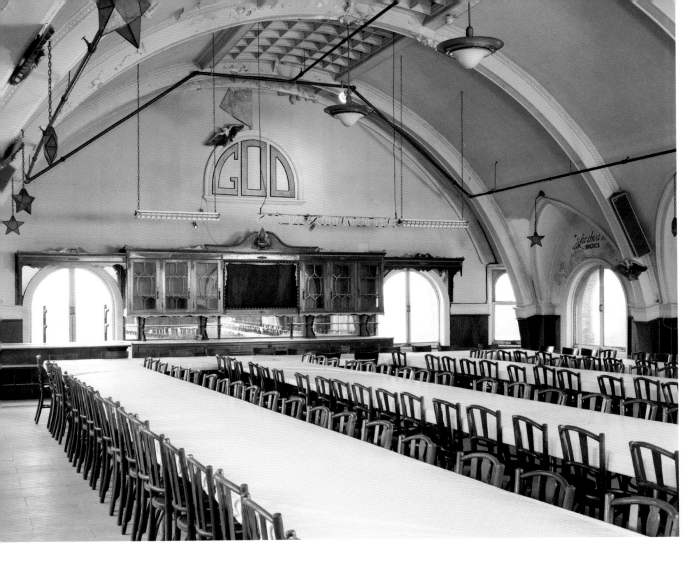

Plate 1.13
Divine Lorraine Hotel, banquet
hall, 2002 (HABS)

generation of positive consciousness." Father Divine initiated the banquets during the Great Depression as a way of satisfying the deep hunger of his mostly poor followers and revealing the tangible bounty of earth. The banquets are still held every Sunday, although they are more private now. Until her death Mother Divine, a white woman born Edna Rose Ritchings, the second wife of Father Divine, sat at the head of a table long enough to seat sixty or seventy people. Father Divine's place is set next to Mother's, and his food is served and drinks poured at the empty place setting, for he is considered present.

The Unity Mission Church, Home and Training School, with Father Divine's pristine office upstairs and alabaster walls downstairs, is an Italianate mansion built by Albert Disston, the son of saw magnate Henry Disston, in North Philadelphia near the corner of 16th Street and West Oxford Avenue. Peace Mission members maintain the mansion with the skill of trained preservationists, as if to seal it in time. Primiano, who for years has been engaged in an ethnographic study of the Peace Mission, classifies this instinct as a "theology of material culture and preservation." Following Father Divine's lead, Peace Mission members have preserved—as if in amber and through seemingly invisible labor—a layer of Philadelphia history. In these buildings, we encounter Philadelphia's particular robber-baron era, populated as much by paternalistic capitalists like Henry Disston, who looked after his workers' welfare as a means of fending off unions, as by the purely avaricious. A century ago new money flooded the area west of Broad Street in North Philadelphia. While deindustrialization destroyed much of the evidence of Gilded Age wealth, Peace Mission members have drawn that layer forward while simultaneously adding a layer of communal religious life and Civil Rights activity. From the 1940s to the present, Father Divine's missions, schools, and businesses stretched across the city, from North to South to West Philadelphia. The composition they formed—of Gilded Age abundance maintained with fastidious precision amid profound decline and poverty—today appears surreal.

Not every place in the Hidden City is so well, or intentionally, preserved, of course. Much of what survives, like the balcony of the Girard Theater discovered in the grocery aisle of the Fine Fare near 7th Street and Girard Avenue, has done so by accident or blindness or as a gift from a city rich enough to endure but too impoverished to erase and start again. Time stitches on urban layers even as it rips them away. Thus in the Hidden City the explorer can find herself seemingly in several different eras at once. The most indelible material culture of the Peace Mission banquet is based in 1940s-era Americana: patriotic, triumphant, old fashioned enough to be richly textured. The food itself is a product of American cookery infused with the Japanese macrobiotic techniques Mother Divine studied in the 1980s in order to purify the bodies of her followers. The ingredients are grown on the Peace Mission farm at Woodmont, and the dinner is served

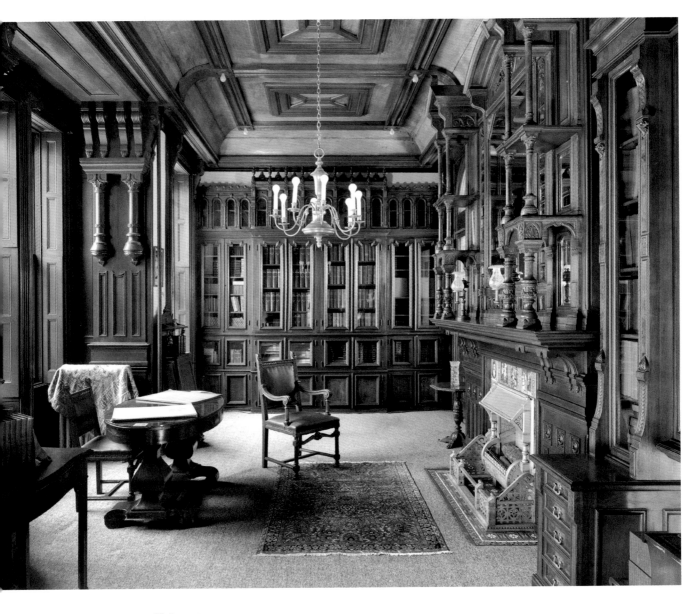

Plate 1.14
Unity Mission Church,
Home and Training School,
library, 2002 (HABS)

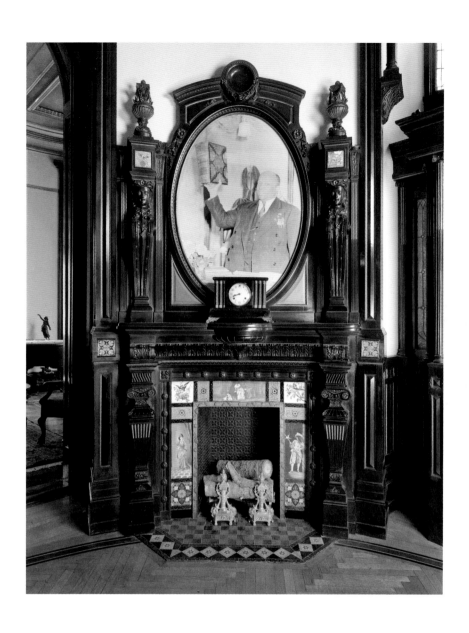

Plate 1.15
Unity Mission Church,
Home and Training School,
fireplace, 2002 (HABS)

family style, each person sharing in the eucharist and passing it to the next person. (The coconut cream pie is particularly spectacular.) Favorites from the American songbook play over the public address system. The experience is like discovering a rich lode of fossils in the bedrock of Philadelphia.

You don't need geological equipment to discover it, however. Dr. Primiano secured a place for us at a Peace Mission banquet on a November Sunday a few years ago, where we joined about fifty others, most of them members of the Peace Mission. Primiano reminded us that we were welcome so long as we followed the rules, which include a ban on words that contain "hell." "Peace," and not "hello," is therefore the desired greeting.

Behind the head of the table, on a stage where Father Divine once spoke, someone fidgeted with audio equipment. Then a recording from the 1950s came on, and Father Divine's voice swelled beneath the scratches. Around the table sat white and black women in their seventies and eighties, some wearing the red, white, and blue stewardess-style suits of the "Rosebuds," virgins consecrated by Mother or Father Divine. They listened and responded as if Father Divine were in the room. The hidden world of the Peace Mission is no less vital, or sublime, than the Wanamaker Organ. Father Divine's enduring presence in it, like the sound of the organ recital in the busy department store, disturbs our notion of time. The past trespasses on the present.

The banquet guest cannot be completely comfortable. His presence, too, is a form of trespass on someone else's world. The Peace Mission asks you to account for yourself. Guests at the Communion Banquet are asked to stand and offer a message to Mother and Father Divine and everyone present. Like the Gilded Age mansion so tenderly preserved despite the near collapse of so much around it, this act feels surreal. Years after the closing of their hotels and cafeterias, including the Divine Lorraine Hotel on North Broad Street and the Divine Tracy on 36th Street in West Philadelphia, few can imagine the intricate community the members of the Peace Mission once inhabited. It is sometimes hard to shake the melancholy of the Hidden City.

A similar melancholy for a lost time greets the visitor to the Church of the Advocate at 18th and Diamond Streets in North Philadelphia. Opened in 1897, a Gilded Age interpretation of high European religious architecture, the Advocate was a flashpoint setting in the Civil Rights movement of the 1960s and 1970s. Both elements have experienced a decline in vitality. Religious life was deflected to large, newly built evangelical congregations, leaving even this National Historic Landmark in a state of uneven maintenance. The Civil Rights movement, drained and then reborn, in somewhat different settings, as Black Lives Matter, shrouds the church in the ache of what was or, worse, what might have been. Yet a visit to the Advocate is exhilarating. A set of 1970s murals depicting the black struggle through biblical narratives contrasts with the indelibly French-inspired

architecture, authentic in its own right. The paintings are a slash across the stone, brilliant blood of anguish and love.

Designing the church in the last decade of the nineteenth century, the architect Charles M. Burns was inspired both by the artistry of the English Ecclesiastical movement and the cross shape, flying buttresses, and proportions of the Cathedral of Our Lady of Amiens and other fourteenth- and fifteenth-century French Gothic churches. The result is the Advocate's original otherworldly juxtaposition: French texture overlaying an American street corner, in a neighborhood of factory workers, clerks, and foremen.

The original leaders of the Church of the Advocate pioneered the Free Church principle. By abolishing the practice of renting pews, they opened the church to everyone, regardless of class. The egalitarian sensibility is not necessarily apparent to the visitor now, and yet it set the stage for a liberal church life that brought in an African American priest, Father Paul Washington, to lead the mixed-race church in the 1960s. Father Washington hosted major Black Power and Black Panther conferences, and the church became a refuge for Civil Rights workers. This history is legible because of the murals Washington commissioned in the 1970s from Walter Edmonds and Richard Watson, who depicted the black experience in America, from slavery to Civil Rights, as a biblical cycle. A booklet, "Art and Architecture of the Church of the Advocate," records the spirit behind the commission. During the Civil Rights struggle, "there were people who came into the church, and as they looked around they saw nothing and no one, including figures in the stained glass windows, with whom they could identify," Washington explained in an interview when the murals were completed. "I heard that so many, many times, that my mind began to look back into history, and I realized that we could see the black experience revealed and defined in religious terms." The visitor to the church experiences this juxtaposition— the imagery of slavery and traditional bible-themed stained glass; the Passover story of Exodus and the rebellions of Nat Turner and Toussaint L'Ouverture; and Genesis 1:1, depicted by Watson and inserted into the French-style transept, with Edmonds's depiction of slavery in the foreground. "A man of sorrows and acquainted with grief" is the biblical text, from the book of Isaiah, that Edmonds illustrates with his mural.

Perhaps more than any group of people in Philadelphia's history— apart from the original Lenape, decimated by white deceit and disease—the black citizens of North Philadelphia have been intimately familiar with sorrow and grief. When that grief bled into violence on August 28, 1964, and thousands descended onto Columbia Avenue to loot and destroy the retail businesses there, Father Washington tried unsuccessfully to calm the rage. Columbia Avenue, the city's premier jazz strip, was devastated. Even today, more than half a century later, the pedestrian walking west along the avenue, renamed in 1987 to honor the Civil Rights leader Cecil B. Moore, can read the anguish in the vacant lots and buildings.

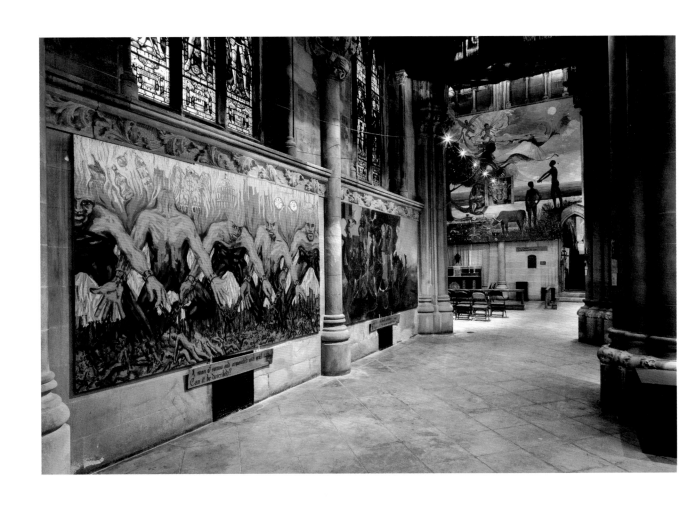

Plate 1.16
Church of the Advocate, nave with
paintings by Walter Edmonds and
Richard Watson, Diamond Street, 2015

Plate 1.17
Church of the Advocate, sacristy,
2015

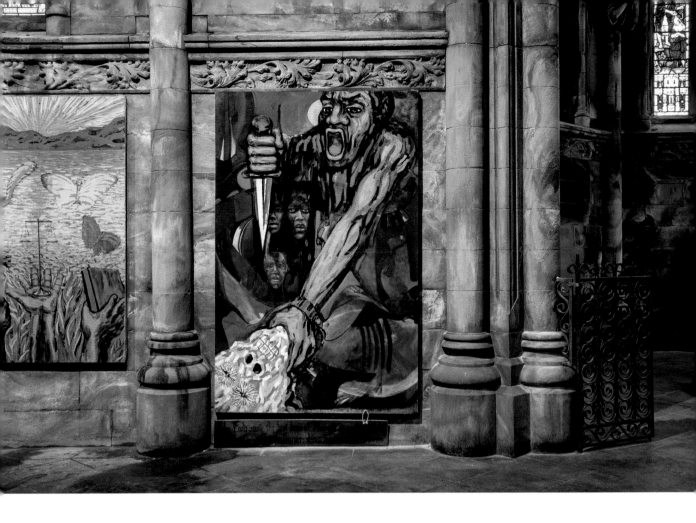

Plate 1.18
Church of the Advocate, "God chose
the weak to confound the strong,"
painting by Walter Edmonds, 2015

Moore, a lawyer and head of the Philadelphia branch of the National Association for the Advancement of Colored People, turned the rage into direct action. The following year he launched a campaign to integrate Girard College, a boarding school for needy white boys three blocks from Columbia Avenue. With its imposing stone wall and monumental architecture borrowed from the ancient world, Girard College, still in operation today as a charitable boarding school for children in grades one to twelve, is one of the city's most visibly alluring and yet hidden landmarks. (Indeed, it is both a National Historic Landmark and a Philadelphia Landmark.) Here, in the jumble of North Philadelphia, amid row houses and commercial streets that are constantly evolving, Girard College appears, like the ancient ruins of Rome, as an incision in the urban fabric. Yet this is an illusion, for the city grew around Girard College rather than the other way around. The college's enduring façade hides decades of upheaval, marked by the Civil Rights protests led by Moore, which forced the school to abide by a court order to enroll black boys (and later girls of all races), and a contemporary financial crisis that threatens its longevity.

In the first decade of the nineteenth century, Philadelphian Nicholas Biddle, serving as part of an American delegation in Europe, traveled to Greece. Moved by the classical architecture he discovered in ancient ruins there, and the elemental democracy it embodied, Biddle decided that the young United States should emulate it. Returning to Philadelphia, he transformed Andalusia, the estate of his wife's family along the Delaware, with Greek porticos. As president of the Second Bank of the United States, which held the deposits of the nation's treasury, he demanded that architects submit only Greek Revival plans for its headquarters on Chestnut Street. William Strickland (trained by Benjamin Latrobe, who had designed the Greek Revival Fairmount Water Works) won the commission.

Under Biddle's considerable influence, and inspired by the skill of architects like Strickland, Thomas U. Walter, and John Haviland and the hope that America would embody the democratic spirit of ancient Greece, Philadelphians continued to commission Greek Revival buildings. One of the most elegant, designed by Strickland in 1832, is the Merchants' Exchange, which still stands at 2nd and Walnut Streets. The Merchants' Exchange, the first stock exchange in the United States, is noted for its striking semicircular portico, mosaic tile exchange floor, sweeping exterior staircases, and "birds nest crown," copied directly from the Choragic Monument of Lysicrates, built around 334 B.C.E. near the Acropolis in Athens.

Biddle benefited from the intense drive and business acumen of Stephen Girard, an immigrant from Bordeaux, in France, who arrived in the city in June 1776. Girard quickly developed a knack for making money, a skill he honed by careful study and observation. He made a long call on the China trade and figured out how to protect it. He understood the new nation's need for credit and took home the rewards. He sensed the

potential of coal, bought mining fields, and then—with irascible spirit in the last years of his life—invested in the nascent railroads to bring the coal to market. When Girard died in 1831, he was worth $7.5 million, which, adjusting for inflation, makes him one of the wealthiest men in the history of the United States.

Girard willed most of his money to local charitable institutions and the City of Philadelphia, which was directed to manage and invest it. The largest chunk, $2 million, was dedicated to the development and construction of a school for "poor, male, white orphans": Girard College. Biddle put himself in charge of building the school and moved the site from the one stipulated in Girard's will, 11th and Market Streets, to a much larger and more accommodating field near another reform institution, Eastern State Penitentiary. He ignored Girard's specific instructions for a modest, unadorned campus in order to hold an architectural competition, inviting the best designers to submit ambitious plans. Thomas U. Walter won the competition in 1833. Two weeks later Biddle persuaded him to scrap his submitted design and start over, making the main building, Founder's Hall, a fully colonnaded version of a Greek temple. The next year, excavators went to work quarrying the needed marble. Then the politically ambitious Biddle, effete, literate, liberal-minded, the ideological heart of the Whig party, hit a wall named Andrew Jackson, populist Indian killer, Democratic scourge of the high-minded eastern elite. While Biddle sent Walter and others on junkets to study the best schools in Europe, Jacksonians at all levels of government blocked his every move and mired the project in popular protest and official interference. The "Bank War" between Biddle and Jackson threatened to scuttle plans for Girard College. Biddle lost his bank, his fortune, and his life before the school opened to one hundred students on January 1, 1848. But some elements of Girard's vision had endured: The Greek temple and outlying buildings were surrounded by a wall "fourteen inches thick, and ten feet high," as the will stipulated, and only white boys were allowed inside.

When Cecil B. Moore launched his campaign to desegregate the school, the wall became the literal and symbolic object of protest. For weeks, stationed outside the wall on Girard Avenue, Moore choreographed a relentless protest, pitting a man's explicit will against the legal requirement of due process of law. On August 3, 1965, Martin Luther King Jr. joined the protest (against the wishes of Moore, who was opposed to King's commitment to nonviolence). A monumental legal case followed. Judge Joseph Lord ruled in 1967 that the will had to be broken in order to protect the civil rights of African American citizens. (Lord's clerk was David L. Cohen, later an architect of the rise of the Comcast Corporation.)

The wall had already acquired symbolic power in the 1930s, when the demographic makeup of the surrounding neighborhood began to change from majority-white Catholic of Irish and German descent to

Plate 1.19

Girard College, Founder's Hall, anthracite coal from Girard Estate Lands, a source of the wealth that was directed toward the creation of the school, Girard Avenue, 2009 (HCF)

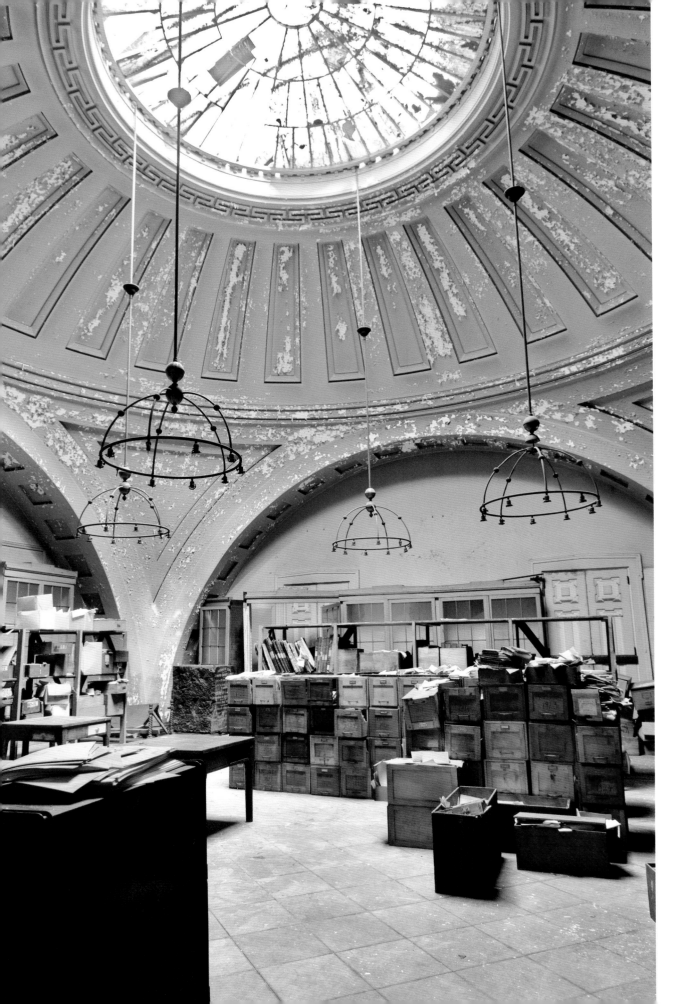

Plate 1.20 (opposite)
Girard College, Founder's Hall,
archives, 2009 (HCF)

Plate 1.21
Girard College, Founder's Hall,
archives, 2009 (HCF)

Plate 1.22
Girard College High School,
animal specimens, 2015

Plate 1.23
Girard College, library, 2015

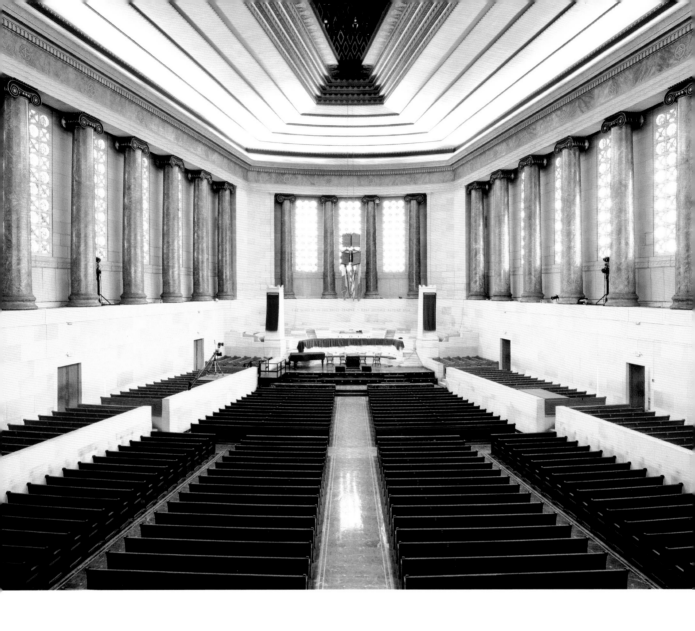

Plate 1.24
Girard College, chapel, 2015

considerably poorer and African American. Poverty devastated many sections of Philadelphia in the early years of the Great Depression. This was one. The demographic shift meant that black boys, many of them in need, were living just on the other side of the wall from an institution that could help them but wouldn't.

The changing demographics had incited another, opposite, protest a few decades before, around the adjacent Catholic Church of the Gesú. Built in 1888, at the height of Philadelphia's ambitious nineteenth century, Gesú is a kind of Jesuit cathedral. The Gesú church was one of hundreds of churches, rectories, schools, convents, hospitals, and universities that together formed a parallel Catholic world, the largest of any American city. If we imagine that the hundreds of thousands of Catholics in Philadelphia animated this world, and the buildings embodied it, we might say that the parish system was an invisible skeleton, a hidden armature of the Catholic city.

The clerics of the Archdiocese meant this parallel world to be permanent. They didn't foresee what might happen when parishioners moved out to new parishes built far from the center of the city and non-Catholics moved in. If those non-Catholics were African American, panicked clerics, seeing their flock dwindling, were known to ally with racist neighbors to try to stop this process. This is what took place in the Gesú parish in the 1930s.

Realtors hoping to cash in on the upheaval, exploited the fears of white homeowners in the Gesú parish by persuading them to sell quickly, and low, lest their houses lose all their value: a classic example of "block busting." The realtors then divided single-family homes into apartments and rented them to African Americans at heightened rents. Around 1935, parish priests, unwilling to bring African American neighbors into the church, publicly denounced the presence of blacks in the neighborhood and pressured parishioners not to sell or rent their houses to black people. In one instance, Father James Maguire, acting as head of the Gesú Parish Improvement Association, along with Father Thomas Love, forced a foreclosure on a neighborhood resident, James Gorman, for renting his house to a black man.

"We must not give up our houses without a mighty struggle for our rights," Maguire wrote in a petition. Newspaper headlines in the black press in the early 1940s—"White Priests Admit Anti-Negro Drive," "Clergy Lead Hate Crusade"—bristled as Girard College officials joined the Gesú movement against blacks.

The reactionary protest inspired the work of Anna McGarry, a Gesú parishioner who dedicated herself to the Civil Rights movement, but it also amplified the message that the Catholic Church was not open to integrating African Americans into parish churches and schools. Though it remains in use as part of the campus of St. Joseph's Prep School and is therefore a legible part of the hidden skeleton of the city's parish structure, Gesú in 1993 became one of the first parish churches (and schools) to be closed by the Archdiocese of Philadelphia.

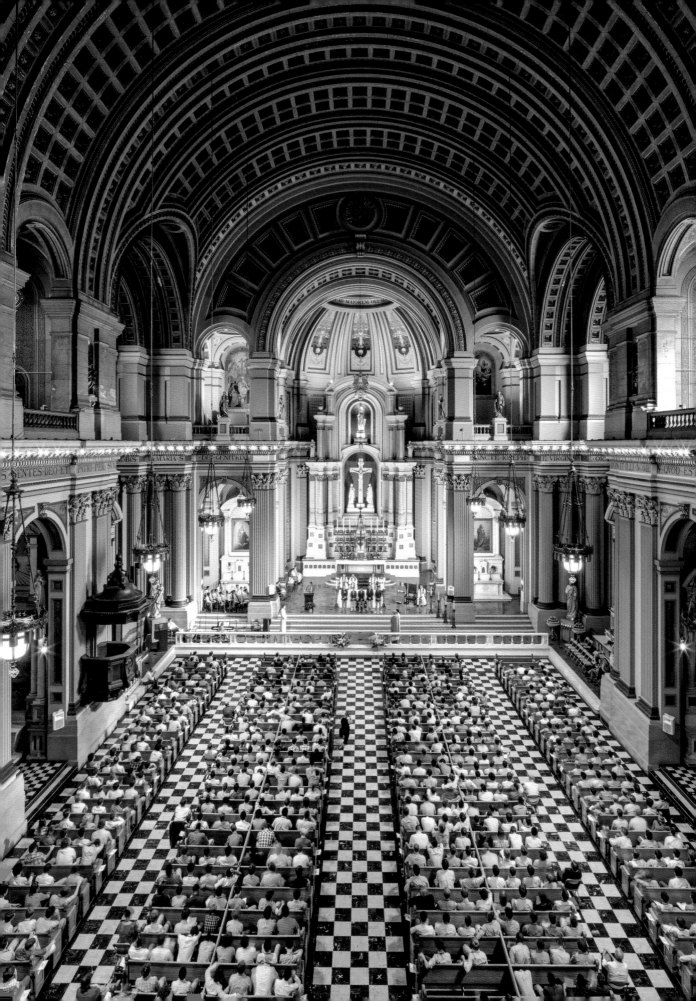

Plate 1.25 (opposite)
Church of the Gesú, interior
looking toward altar,
North 18th Street, 2016

Plate 1.26
Church of the Gesú, students
from St. Joseph Prep School
receiving Communion, 2016

Plate 1.27
Church of the Gesú, baptistry,
2016

Both Gesú and Girard College, monumental products of the long nineteenth century, mostly hidden from the daily life of twenty-first-century Philadelphians, loom over their North Philadelphia neighborhood. The juxtaposition of their monumental architecture to the row house–lined street is an apt metaphor for the relationship of the Hidden City to the quotidian one. Abundant elements of the Hidden City, many the products of the immense wealth of the nineteenth century, are in tantalizingly close proximity to curious people. We see them but often lack a language of interpretation.

A LAYER THAT PEEKS THROUGH

As late as 1825, when the Greek Revival was asserting itself in the drafting room, the city of Philadelphia was still clustered around its Delaware River port, source of wealth and connection to the world. In the outlying districts of Northern Liberties, Kensington, Germantown, and Frankford, economic life (and therefore social life and culture) was tied to farm fields and small water-powered mills. But even then most of Philadelphia's abundant creeks ran free.

Inventors and makers took hold of the creeks to power their dreams and opened the floodgates of the long nineteenth century. In the 1820s the creeks were put to work as a new urban musculature, powering mills. Wooden culverts were put in place to deliver and circulate water across the city. But as Philadelphia engineers learned to turn steam into power for machines and locomotives, railroad lines replaced the creeks, and real estate developers, in alliance with politicians and powerbrokers, took hold of the land. They graded hills, expanded the grid, and connected every house to a combined water and sewer system. They managed the city's waste by sending it back out to the rivers, burying the old creeks in pipes so large they look like subway tunnels.

Concealed beneath the city's streets, like veins and arteries beneath the skin, are these giant culverts, extensively researched by the Philadelphia archivist and writer Adam Levine. Levine's research shows how the great culverts of the combined sewer-water system were installed as the grid was extended farther west, south, and north—meadow and forest graded, creeks subdued. This is the hidden armature of the grid. Occasionally we glimpse other facets of the city's hidden nineteenth-century armature, like bones piercing its skin: the skeleton of the railroads; the skeleton of Philadelphia's horizontal industrial system, with adjacent firms and factories each feeding the next; the skeleton of the Catholic parish system, with its defined landscape of church-rectory-school and row houses; the skeleton of racist land-use law that restricted where certain people could live. All gave form to the city. Now, layered on top of and across each other, and

Plate 1.28 (following spread)
Mill Creek Sewer, brick and stone,
West Philadelphia, 2016

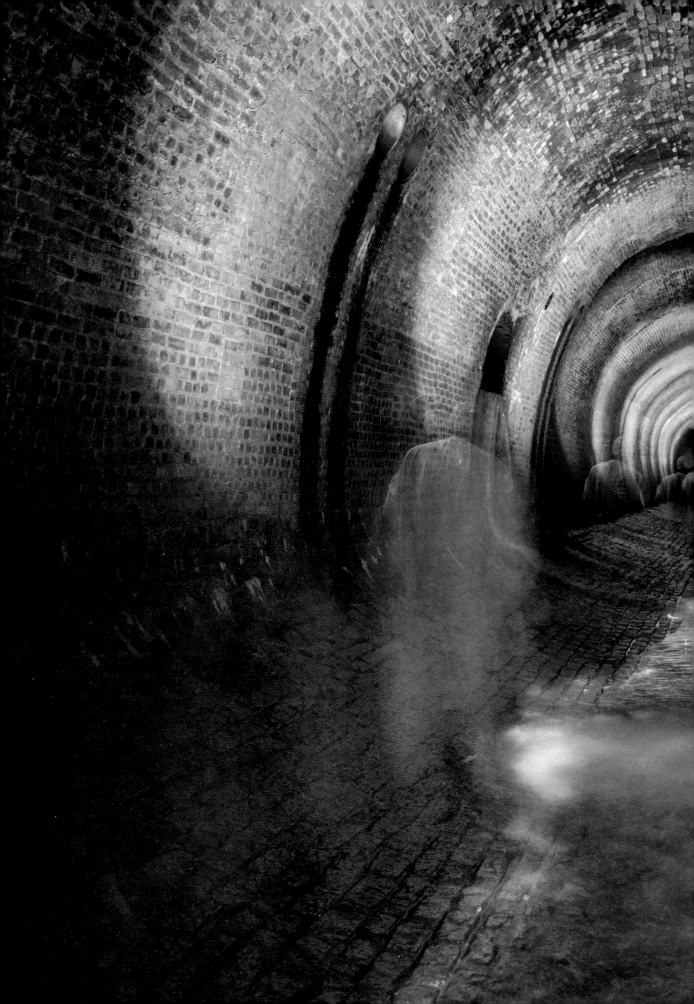

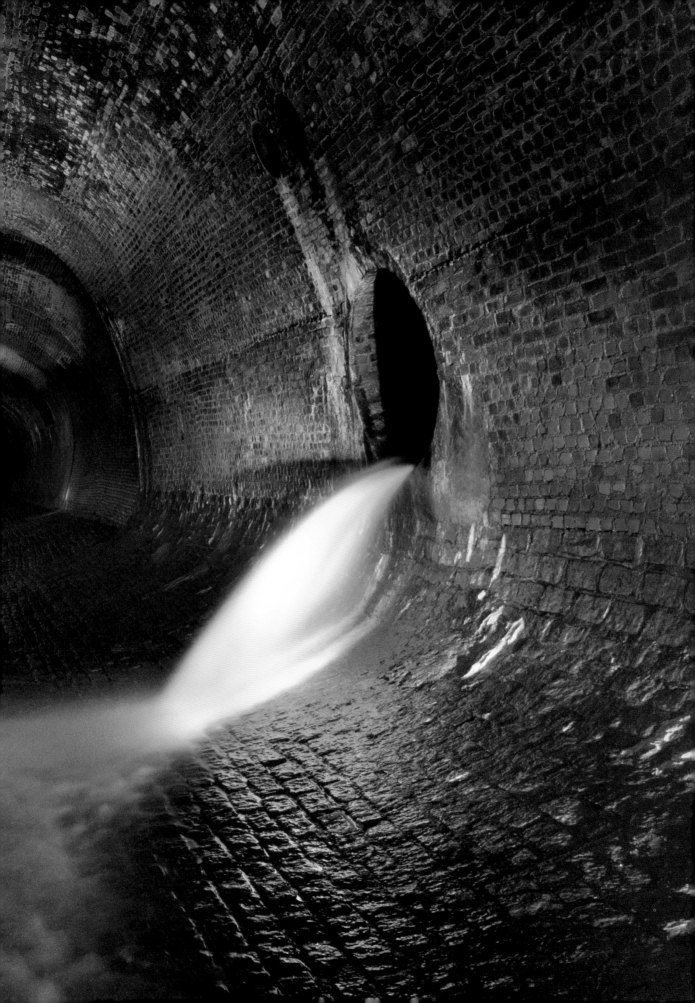

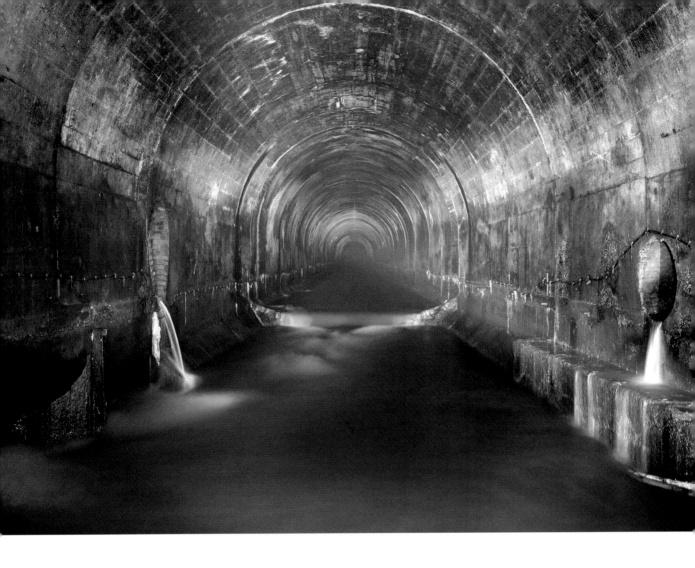

Plate 1.29
Mill Creek Sewer, concrete-lined,
West Philadelphia, 2016

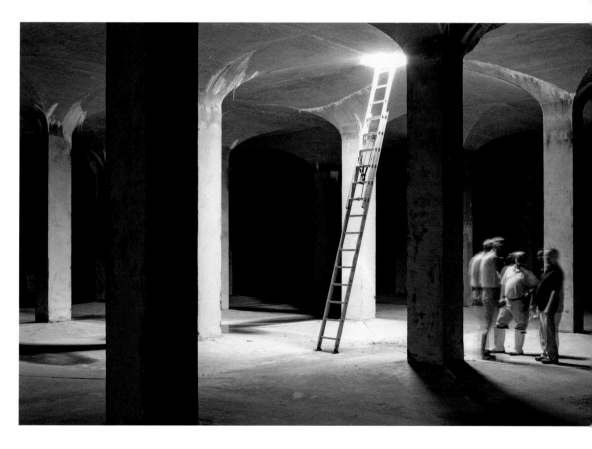

Plate 1.30
Former water filtration chamber,
access for inspection,
Northwest Philadelphia, 2016

Plate 1.31
Gravestones from Monument Cemetery,
Delaware River bank at Betsy Ross
Bridge, Delair Bridge in distance, 2015

———

Plate 1.32
Gravestone from Monument Cemetery,
rope, Delaware River bank at Betsy
Ross Bridge, 2015

only partially visible to the passerby, they emit a collective hold, another element of the persistent past.

Draftsmen working for the real estate developers and gas and water utilities in the mid-nineteenth century would often run into burial places and cemeteries—old churchyards, unmarked graves, burial grounds for African Americans, for German Lutherans, for yellow fever victims, for Civil War soldiers, for impoverished writers. They would have to contact the next of kin to arrange for the removal of the bodies and reburial with a headstone or grave marker. Most often no one would be found, and these bones would be resettled in unmarked graves. Many were lost or stolen, their original markers tossed aside. This practice continued into the 1950s, when City officials deeded Monument Cemetery in North Philadelphia, the city's third-largest burial ground, to Temple University for ball fields and parking lots. Workers moved the remains of twenty-eight thousand people to Lawnview Cemetery north of the city. Only three hundred of them, those whose relatives could be found, were reburied with their original headstones. The rest of the grave markers, many with intricate Victorian-era carvings, were dumped below the Betsy Ross Bridge to be used for riprap, a bulwark against erosion.

In 2016, twenty-five years after activists in the Callowhill neighborhood imagined a new use for the Reading Viaduct, a train trestle that last functioned in 1984, workers began transforming a short, one-quarter-mile section of the elevated railway controlled by the City of Philadelphia into the Viaduct Rail Park. Here is another way the city makes use of its old stones. The remaining mile or so of elevated tracks (running north–south) will remain a pure ruin, as will a mile-and-a-half section of the submerged "City Branch" railway, which connects to the Viaduct at Broad Street. City officials haven't yet found a way to wrest control of the elevated section from the Reading Company, which still owns it and other railroad holdings. But Philadelphians have a long habit of climbing through the security fence for a stroll through the skyway meadow or a turn on the rope swing someone has hung from one of the catenaries. The submerged City Branch, which runs along the route of the city's earliest (circa 1832) rail line, is owned by SEPTA (Southeastern Pennsylvania Transportation Authority), Philadelphia's transit agency. Some advocates wish to see it put back to transit use for rail or high-speed bus; others, particularly those who have lobbied to convert the Viaduct into public space, wish to see it become part of a three-mile linear park, a stroke of green across the center of Philadelphia. SEPTA has not released any definitive plans.

The ruins of Philadelphia's two most prominent consolidated railroads, the Reading and the Pennsylvania, are not exactly hidden. Philadelphia's regional rail system, operated by SEPTA, comprises a sizeable portion of both the Reading and Pennsylvania passenger networks. The recent upsurge in the shipping of crude oil from the Bakken Formation in

Plate 1.33
Reading Railroad City Branch,
entrance to tunnel, 2015

Plate 1.34 (following spread)
Reading Railroad City Branch,
archways near Fairmont
Avenue, 2015

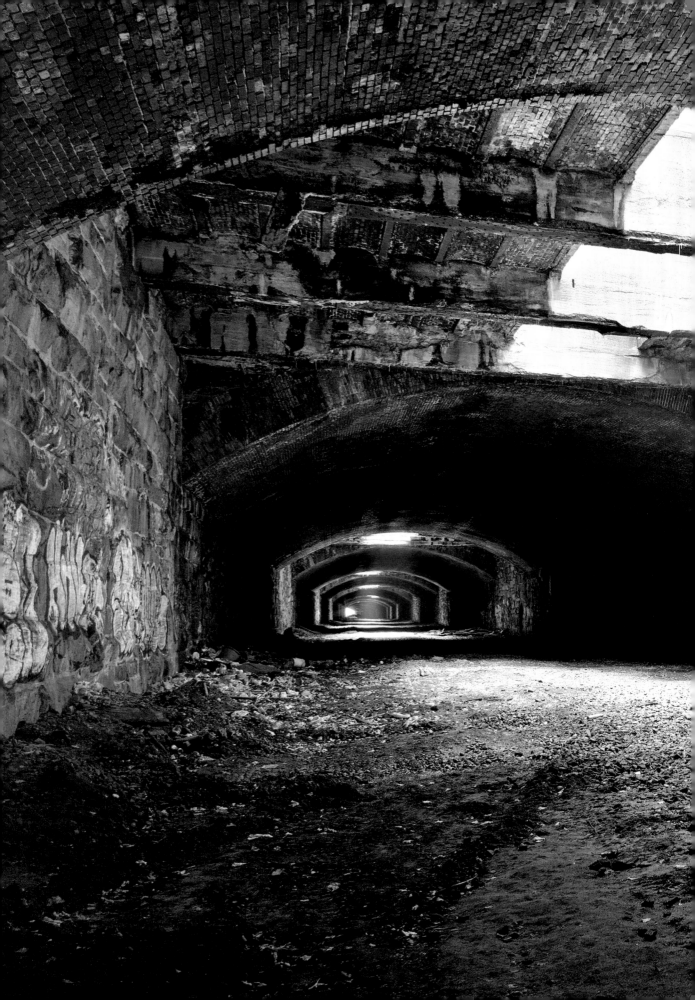

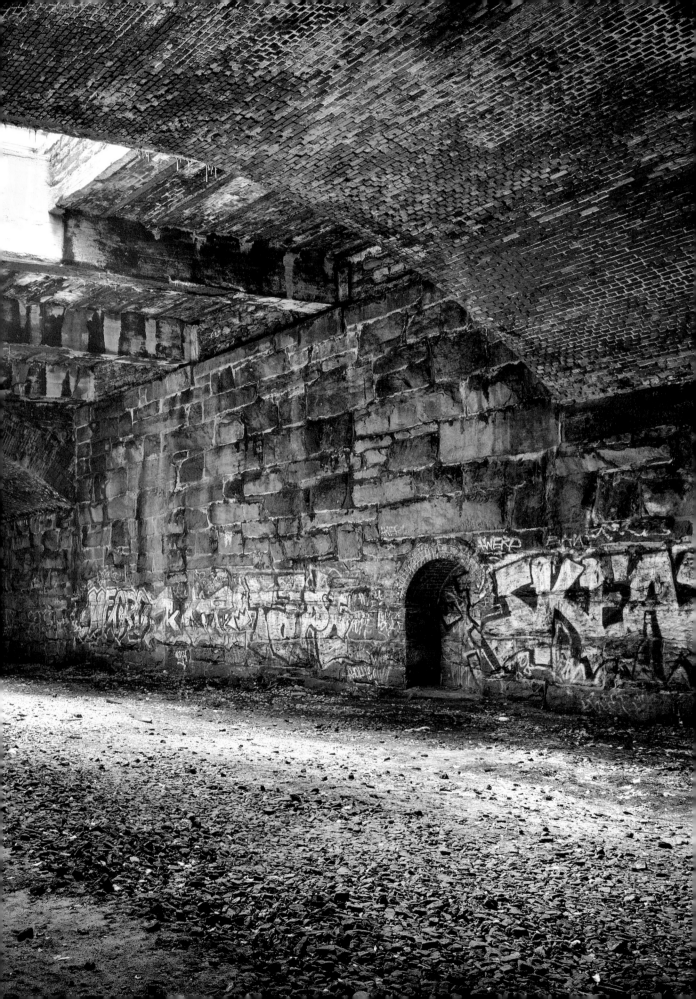

Plate 1.35
Reading Railroad City Branch,
layers of structure and vegetation,
near Broad Street, 2015

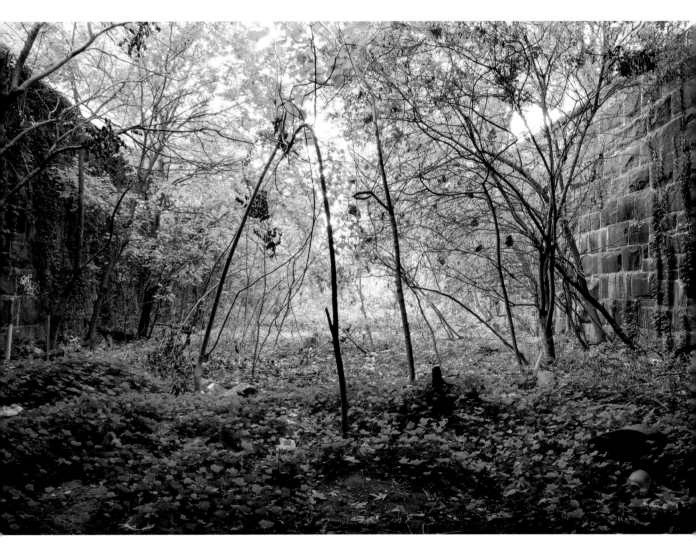

Plate 1.36
Reading Railroad City Branch,
spontaneous garden below
18th Street, 2015

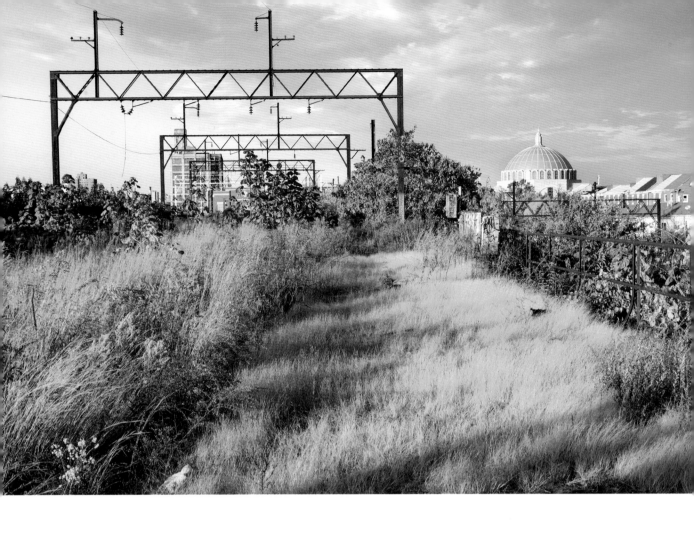

Plate 1.37

Reading Railroad Viaduct,
Spring Garden Street,
dome of the Ukrainian Catholic
Cathedral of the Immaculate
Conception in distance,
2015

———

the northern United States and Canada, in endless chains of black cylinder cars, helps us visualize the intricate web of freight and passenger tracks and bridges that once crisscrossed the city. On freight tracks still in use on both sides of the Schuylkill River, along elevated viaducts and tracks at grade, through tunnels and across bridges, the black ghosts of these two immense railroad systems grind and clamber night and day. (They are ghosts until an accident occurs.)

All this is a mere suggestion of another era, when the Reading and Pennsylvania seemed to shape the totality of time and space. Among the Philadelphia "firsts" Frank Taylor recorded in his *Dictionary of Philadelphia* were some associated with the development of railroad technology, including the "First experimental railroad tracks" (1809), "First successful American-made locomotive" (1832), and "First sleeping car" (1859). "The Pennsylvania Railroad is the single biggest thing that Philadelphia brains, industry, enterprise and foresight have produced," he boasted of the system that was about three times the size of its nearest rival, the Reading, "a pioneer in passenger traffic." According to Taylor's tally a century ago, Philadelphians manufactured locomotive engines, rail cars, and trolley and subway cars, an economy worth $22.7 million. Beyond the physical, invasive totality of these railroad systems and the industrial complexes that supported them was a web of global shipping and passenger transit. Both railroad systems connected to the Delaware River port and fifty-four domestic and international shipping lines.

Yet despite all of this transportation infrastructure and the wealth it produced, Philadelphia never managed to build an expansive subway system. The vision for one was there, briefly. In 1916 the mayor announced a plan, drawn up by transit experts, for a system of twelve lines in addition to the Market-Frankford Subway-Elevated Line. Only one, the Broad Street Line, was ever built. With only the Market-Frankford Subway-Elevated Line and the Broad Street Subway, the short Broad-Ridge Spur, and the bi-state PATCO High Speed Line traversing the Ben Franklin Bridge between Center City and Camden, Philadelphia can, in fact, feel "slow." But the poor system is also a product of the sheer corrupt power of the Organization, the Republican machine that inveighed against the grand plans of the elite if those plans threatened its control. As Thomas Keels demonstrates in *Sesqui!* (2017), the 1926 American Sesquicentennial World's Fair was meant to enable the city to produce grand civic spaces along a new Fairmount Parkway (later the Benjamin Franklin Parkway) and in Fairmount Park, even as the City treasury funded the planned subway system. John Wanamaker, who had organized the Centennial World's Fair in 1876, felt that a great city needed both grand civic spaces and efficient utilities; the Sesquicentennial would force the issue. But the Organization—Wanamaker's political enemy—took over the fair, moved it to wetlands in South Philadelphia, far from Center City (the grounds became Philadelphia's municipal sports stadiums and FDR

Park), and blew the treasury on fair buildings that were finished months after the planned opening in spring 1926. Hardly anyone showed up, and the World's Fair lost millions in gate revenue: so much money that City officials could no longer finance ambitious public works just as the Depression was about to hit. With the City's treasury drained, the 1916 subway plan was scrapped.

Without an effective subway system, people came to favor the provincial neighborliness of the trolley and bus (the Philadelphia habit of thanking the bus driver when exiting is likely born of this sense of familiarity). By the 1970s, the underground areas of Philadelphia mirrored the city above. Stations were dirty and covered in graffiti. With crime on the rise and ridership plummeting in North Philadelphia in particular, officials decided to abandon several stations, including the Franklin Square station of the PATCO High Speed line, which closed in 1979.

In the early 1960s, Nathaniel Burt observed in *The Perennial Philadelphians* that "the Pennsylvania Railroad is the greatest railroad in the world— still." The "still," he went on, was "crucial," for the corporation was on the verge of failing to pay its stock dividend after a century of producing uninterrupted profit for shareholders. In 1968, now demonstrably faltering, the Pennsy merged with the New York Central to form the Penn Central, which declared bankruptcy two years later. Conrail, Amtrak, and SEPTA would pick up the bones.

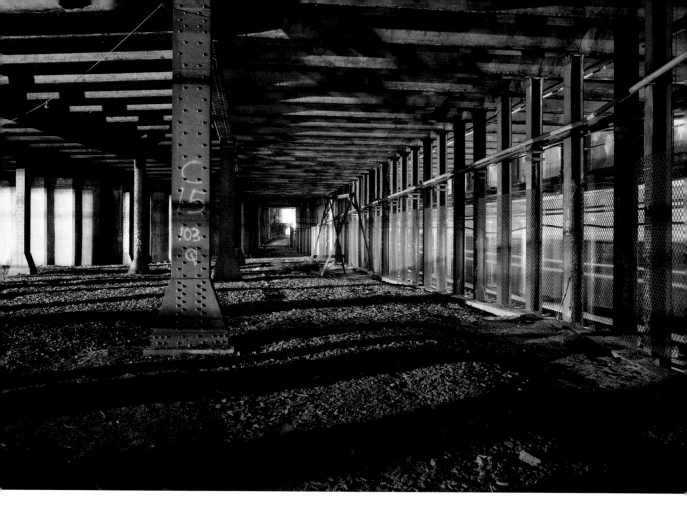

Plate 1.38
Benjamin Franklin Bridge,
Monument Plaza, never-used
trolley station below *Bolt
of Lightning . . . A Memorial to
Benjamin Franklin*, 6th and
Vine Streets, 2016

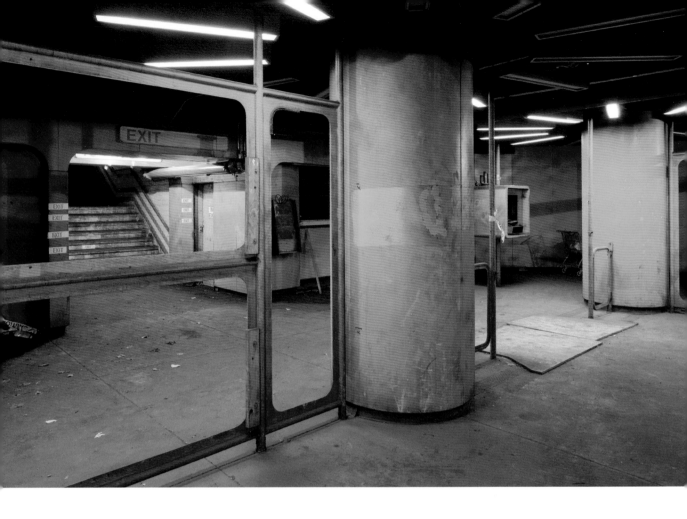

Plate 1.39
Franklin Square Subway Station,
closed since 1979, 2016

Plate 1.40
Franklin Square Subway Station,
phone booth, 2016

City of Living Ruins

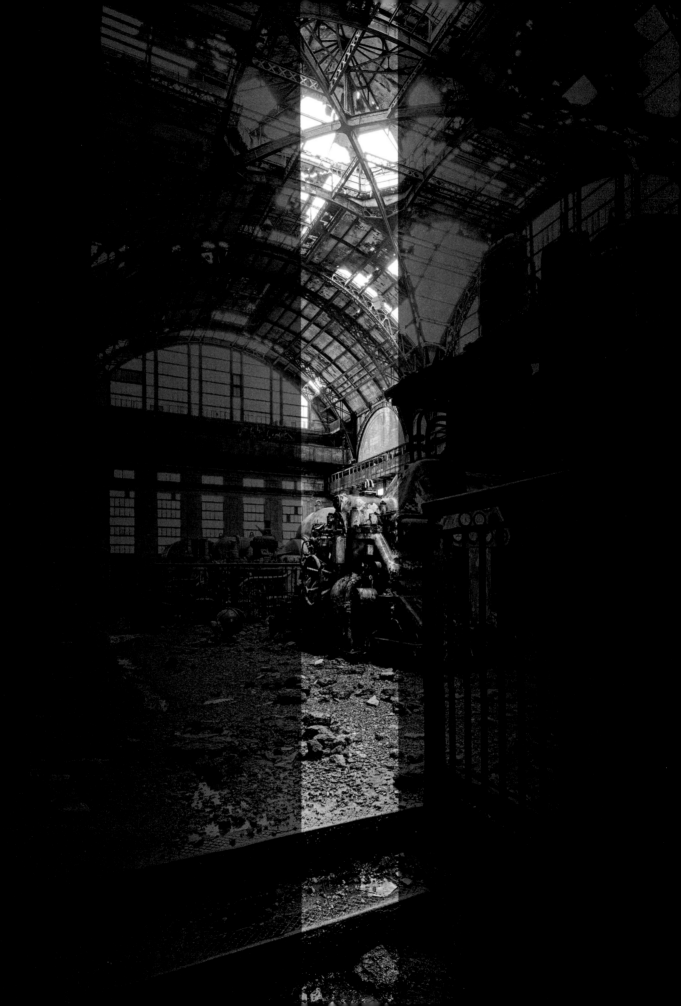

In his book *In Ruins*, Christopher Woodward recalls a ruined stone bridge on an abandoned English estate where he once played as a child. As a young man he returns to the bridge, long out of use, the road overtaken by pasture. "The loose stones, the brambles growing in the cracks, the lush grass, even the dryness of the water-course," he observes, "seemed to be a gentle denial of the purpose for which the bridge was built, a negation of the forward impulse of the high stone arch." Further, he realizes, "In ruins movement is halted, and Time suspended. The dilapidated bridge was the still point of a spinning world which moved forward day by day." For Woodward, the ruined bridge created a feeling of "elated quietude," a melancholic wave of opposite forces colliding: eternal time and finite mortality.

The power to produce such a feeling is one reason we call our Philadelphia ruins—of power plants and prisons, of railroad viaducts and train depots, of factories and mills, of schools and hospitals, of civic buildings and subway stations, of churches and shipping piers—"living ruins." Here all this sits, in startling intimacy, exerting a particular hold on us, whispering to us in a strange, almost religious language, as if reciting an incantation against the rudimentary and the everyday. Woodward notes that Edgar Allan Poe, who lived in Philadelphia during the most productive years of his literary career, discovered this kind of religious language in the Roman Colosseum, "a pulsating source of eternal, magical energy."

In the 1920s the Philadelphia Electric Company planned and built an unprecedented system of power stations, some of the largest and most monumental industrial buildings in the world. Their scale and neoclassical design suggest the apotheosis of civic architecture, buildings meant to embody both progress and permanence. Their function declared that Philadelphia had entered the modern age. Philadelphia Electric engineers placed two of the most commanding power stations, Delaware Station and Richmond Station, along the Delaware River for easy access to shipments of coal. Both have been decommissioned. Richmond, which possesses the form and scale of a grand railroad terminal (though built out to only a third of its planned size), was the setting for some of the most grotesque scenes of *Twelve Monkeys*. As a ruin, it is especially sublime. Rusting turbines lie across the pocked concrete floor like latent beasts.

Inside the stillness of an urban ruin like Richmond Generating Station, consciousness of eternal time mingles with an awareness of finite mortality, and all of a sudden the rest of the city disappears. From handwritten instructions taped to a turret lathe to cheesecake shots inside the rusting lockers, the interior is still invested with the presence of those who built it or

worked the machinery. Decay invites pigeons, hawks, and squirrels. Trees grow in windblown soil, in walls, in mortar. Where the roof has collapsed, shafts of light find pools of water. All of this engages the eye and calls out to the heart. There is no sound, only the smell of accumulated time. The exploration becomes a personal communion with the place. Truly alone, the urban explorer's feeling is akin to being in wilderness.

It is possible to be moved by the experience without reflecting further on the history implicit in the scene. But the awakened explorer begins to develop a consciousness of history rooted in place. Exploration begs for time spent with old maps and directories and in archives, where the explorer's experience thickens with knowledge of the ideas, movements, and innovations that color human life. We might say that the metaphysical city intersects with the physical one; the Hidden City becomes animated with the secret connections that define our world.

Nearby, in 1896 City officials opened Holmesburg Prison, constructed according to the radial design of the Pennsylvania System of incarceration. This approach, based on solitary confinement and moral reflection, was first used at Eastern State Penitentiary in 1829. The fact that this system had failed and had been proven inhumane by the time Holmesburg was built was probably enough to predict the disastrous cruelty that inmates would experience in the decades to follow. Wardens cooked inmates to death in a disciplinary section of the prison known as the "Bake Oven." A University of Pennsylvania dermatologist, Albert Kligman, with the support of pharmaceutical companies and government agencies, experimented on dozens of prisoners with toxic chemicals and pathogens. Guards regularly beat inmates and subjected them to rape and torture. In 1973 prisoners killed the warden and deputy warden. Violence and disorder characterized the prison until the City closed it in 1995, leaving a ruin of crumbling concrete, rust, and peeling paint that could only barely suggest the disturbing history of the place.

A dominant response to ruins like Richmond Generating Station and Holmesburg Prison has been to objectify them as statements on the decomposition of society. The subtitle of Vincent Feldman's photographic exploration of decline, *City Abandoned*, is, fittingly, "Charting the Loss of Civic Institutions in Philadelphia." Similarly, the subtitles of Philadelphia photographer Matthew Christopher's *Abandoned America* series, "Dismantling the Dream" (2016) and "The Age of Consequences" (2014), speak to ruins as evidence of a civilization in decline. Another Philadelphia photographer, Zoe Strauss, has connected ruined spaces to ruined lives in order to demonstrate both the moral cost of economic decline and the resilience and resourcefulness of those forced to make their lives in poverty. There is artistry in the work of these photographers, each of whom frames subjects as formal compositions; the viewer is drawn to them because of the visual and narrative power of decomposition, which suggests that the city has a cycle of life and death that aligns with or mirrors our own.

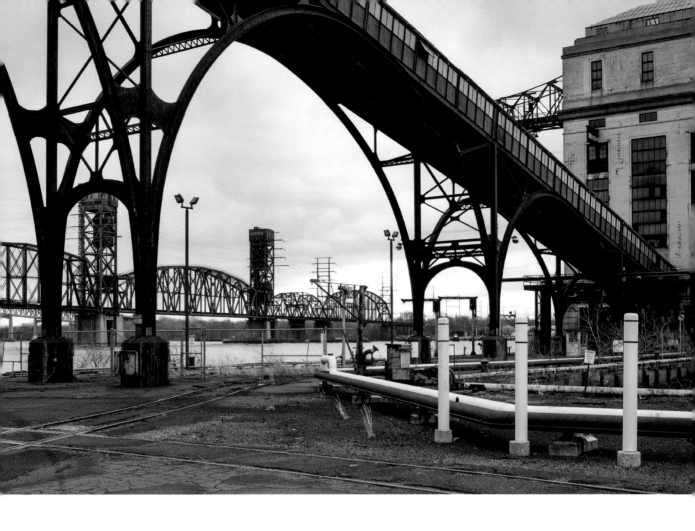

Plate 2.1
Richmond Generating Station,
coal conveyor, with Delair Bridge
in distance, 2016

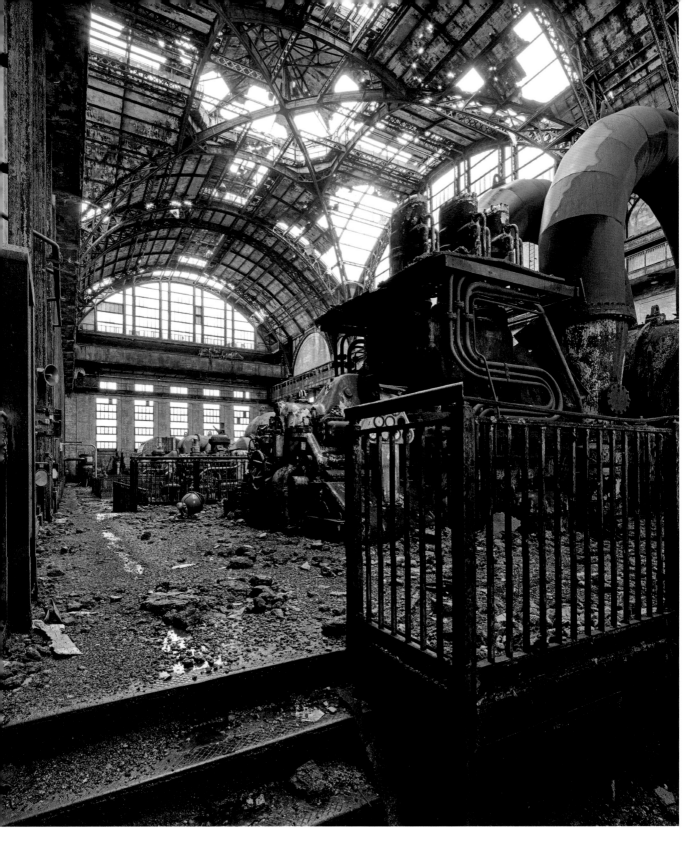

Plate 2.2
Richmond Generating Station,
Turbine Hall, 2016

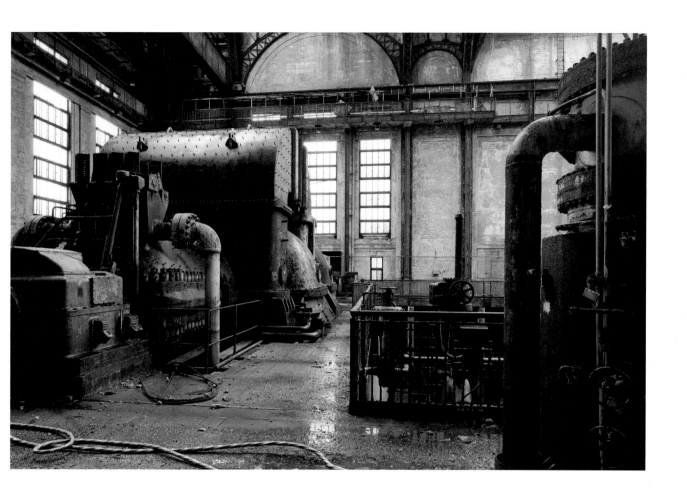

Plate 2.3
Richmond Generating Station,
turbine, 2016

Plate 2.4
Holmesburg Prison, gate locks,
Torresdale Avenue, 2015

Plate 2.5
Holmesburg Prison, visiting area,
2015

Plate 2.6
Holmesburg Prison, holding cell,
2015

Plate 2.7
Holmesburg Prison, guard tower,
2015

Plate 2.8
Holmesburg Prison, view from
guard tower, 2015

Photographers carry on a long tradition of framing ruins as objects of aesthetic beauty, elements of a picturesque landscape. But for centuries ruins have also been the raw material of real life. In the Middle Ages, according to Woodward, in places like Arles and Nîmes in France, Lucca in Italy, and Avila in Spain, people built whole urban districts inside Roman amphitheaters. Sixteenth-century Rome was built with powdered lime made from the burnt marble of the ruined Forum. Modern Athens was fashioned the same way—by appropriating ruins as raw material.

In present-day Philadelphia it is possible to inhabit industrial ruins— not just artists taking over lofts, as they have since the 1930s, or artisans turning an old dye works into a coffee roaster and distillery, but craftspeople carrying them forward as places of production, following their original purpose. This resilience has a lot to do with the diversity of Philadelphia's manufacturers in the long nineteenth century, which included major producers of textiles, tools, machines, steel, automobiles, locomotives, radios, electronics, media, pharmaceuticals, and chemicals. Much of Philadelphia's ecosystem was made up of small to mid-sized companies connected horizontally, with one firm's products feeding the next, as opposed to a single, vertically organized company performing all of the operations under one roof. Industrial decline thus came not in a singular collapse but in fragmented bursts that often allowed for recalibration and innovation. This was particularly true in textile production, where mills, dyers, and finishers, as well as carpet, drapery, and clothing manufacturers, were linked in a web that could withstand losing a strand or two at a time. The Globe Dye Works in Frankford, founded by the Greenwood family in 1865, endured until 2005, well after most other textile firms had disappeared. The artists and innovators who moved in after local developers renovated the complex have immersed themselves in the Globe mill, inspired and awakened by the legacy of materials and the buildings themselves.

During the long nineteenth century and up until World War II, as capital concentrated and large, stockholder-owned corporations began to dominate the American economy, Philadelphia's firms, even the industrial ones, tended to remain family-owned. When times were good, these families, like the Greenwoods, added on to their mills instead of knocking them down and replacing them. When the economy shifted, they made marginal adjustments until it was too late.

Legacy mill and workshop owners, many of them carrying on both civic and family traditions, seem to have been enamored of the long goodbye. John and Tom Wilde opened a yarn mill near Manayunk in 1884. Their descendants kept it in operation until 2008 (they had expanded in 1984). When real estate developers purchased Wilde Yarn Mill in 2012, they discovered a virtual museum of textile manufacturing and invited photographers

Plate 2.9
Globe Dye Works, machine shop
lathe, 2013 (HCF)

Plate 2.10
Globe Dye Works, vat containing
dye granules, 2013 (HCF)

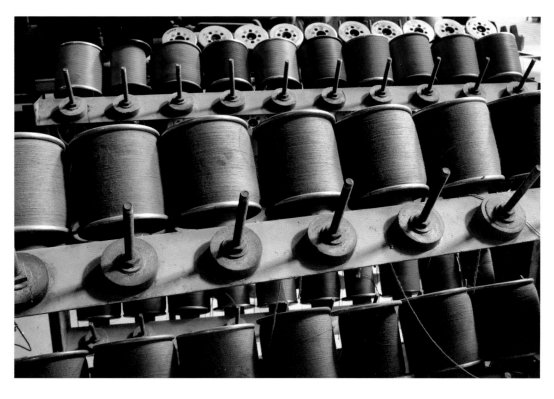

Plate 2.11
Globe Dye Works, spools of thread,
2013 (HCF)

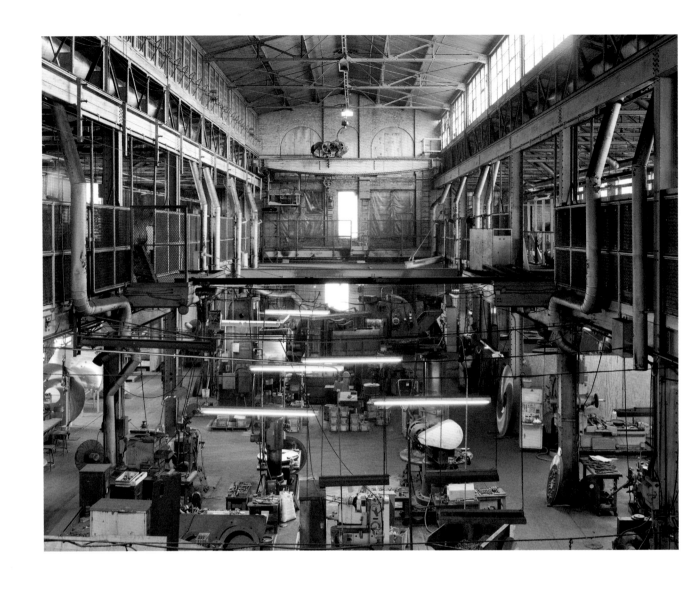

Plate 2.12
Disston Saw Works, machine shop
floor, Tacony, 2002 (HABS)

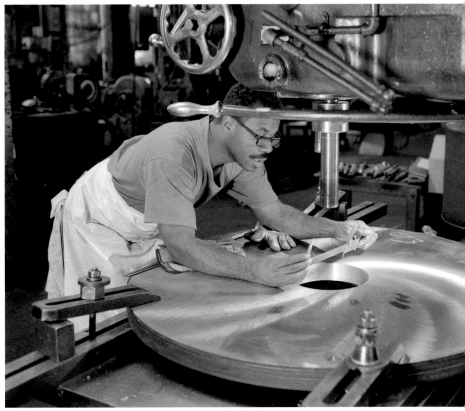

Plate 2.13
Disston Saw Works, large saw
blade on tooth cutting machine,
2009 (HCF)

Plate 2.14
Disston Saw Works, setting
up a blade on a boring mill,
2007 (HABS)

Plate 2.15 (previous spread)
Disston Saw Works, machine
shop wall, 2009 (HCF)

Plate 2.16
Disston Saw Works, infirmary
jars, 2009 (HCF)

in to document it. Fourth- and fifth-generation owners found ways to keep the John Grass Wood Turning Company, at 2nd and Quarry Streets, open into the twenty-first century. (During the 2013 Hidden City Festival, we invited the public in to see the workshop as it was left when the company, founded in 1863, closed in 2003.) Nearby is John Stortz and Son, makers of specialty tools, which opened in 1853. Part of the same horizontal economic system, Grass once supplied Stortz with handles. The present John Stortz continues to operate his family firm from 210 Vine Street, where his employees make paint scrapers, masonry and roofing tools, ice choppers, and gardening implements, even as he considers selling the building and moving out.

Stortz and Son suggests another way in which we might inhabit the contemporary city and the Hidden City at the same time: through the passing down of tradition. Stortz and his employees actively pull the past into the present through adaptation, refining manufacturing practices, applying the latest technology, and seeking new business lines. The firm appears to suspend time, perhaps counterintuitively, through nimbleness and flexibility. Still, when we observe a worker trimming a Stortz hammer claw, or see a saw blade being trued at Disston Precision, a small company that is a descendant of the Disston Saw Works, once the largest in the world, we sense a deep connection to another era, as if the hands of all the bladesmen since Henry Disston opened his first shop two blocks from John Stortz were still present.

Of course, those workers are in a sense ghosts of the ruined economic system that once defined life in Philadelphia. So are the sixty employees of Wayne Mills, who manufacture and dye cotton, nylon, and polyester twill tape and other seam-binding materials for medical equipment and clothing. They are carrying on work that started in their factory building in 1885. Occupying a section of the New Glen Echo Mills complex, Wayne Mills is the oldest textile manufacturer in the city, and the only still-operating manufacturer in the Wayne Junction National Industrial Historic District in lower Germantown. The district comprises thirteen industrial buildings (and one demolished structure), along with the Wayne Junction railroad station, opened in 1884 by the Reading Railroad. From the platform of the now-restored station, we can read layers of the city as we stand in the ruins: the various factories with their original, Dickensian air, with new sections added over the next century, surrounded by even newer ones built around World War I. If we listen as we look, we might hear the sound of a SEPTA regional rail train pulling into the station (which once served points all along the Reading system), along with the rat-a-tat of the Wayne looms, spinning, spinning. We might think of these as the sounds of living ruins.

The presence of so much material culture so close at hand—though less, it seems, each day—points to Philadelphia's conservative culture. For three decades beginning in the 1950s, Philadelphia, so comfortable with

the dimensions of a manufacturing society, pursued a policy of industrial renewal. Officials formed the Philadelphia Industrial Development Corporation (PIDC), a quasi-public agency that sought to protect and grow industrial jobs. PIDC staff met with the owners of firms to learn what resources they would need to expand their plants; they also drew up plans for ambitious industrial parks that would replace old mills and factories. As Guian McKee shows in *The Problem of Jobs* (2008), Philadelphia's protective response to deindustrialization was more strategic and more comprehensive than the approach of any other city.

The PIDC approach indeed protected some industrial jobs, helped to keep the city's port the second busiest in the nation well into the 1950s, and delayed a complete collapse. But it ran into systemic roadblocks. First among these was the craft and specialty nature of much of Philadelphia manufacturing, a legacy of the nineteenth century. More Philadelphia firms were like the Cunningham Piano Company, a family-owned concern that once made—and still repairs—high-end pianos for serious musicians. This kind of firm, like Wayne Mills, survived not by ramping up for mass production but instead by exploiting a specialty market. The backward gaze of political rhetoric and public policy preserved a semblance of a fabled way of life, but it also blinded business leaders and politicians to the structural upheaval of the global economy. The bulwark of the PIDC was too small and too late to make Philadelphia an exception.

As the American economy transitioned from manufacturing, East Coast peers Boston and New York pursued an economic development policy that encouraged growth in the service economy. Those cities, in part because of that early action, have completely replaced the jobs lost to deindustrialization in the twentieth century. Because Philadelphia officials did not reorganize the structural economy (as they had, in fact, reformed the political structure through charter reform), fewer people work in Philadelphia today than did when Nathaniel Burt wrote about the "overwhelmingly depressing" city.

The industrial economy at the end of its run was ugly and certainly depressing. Firms facing extinction could not invest in machinery, technology, or office furnishings. They could not fix their sidewalks or repoint their brick, no matter what programs PIDC touted. And Philadelphians wanted no more of it; they came to despise not only the grime but also what was underneath it. Today, the impulse is almost unanimously the opposite: the industrial age serves as inspiration. This feeling, so apparent at a place like the Globe Dye Works and at a legacy industrial concern like Wayne Mills, is a kind of dual trespass, where the past elbows in on the present, and, like urban explorers breaking into an old factory, people are drawn into the past. We inhabit a world others adapted from those who came before them. At the same time, that world presses in on us, defining the very architecture of our lives. Here, time and the city collide in dynamic tension.

Plate 2.17
John Grass Wood Turning
Company, front elevation,
2nd Street, 2013 (HCF)

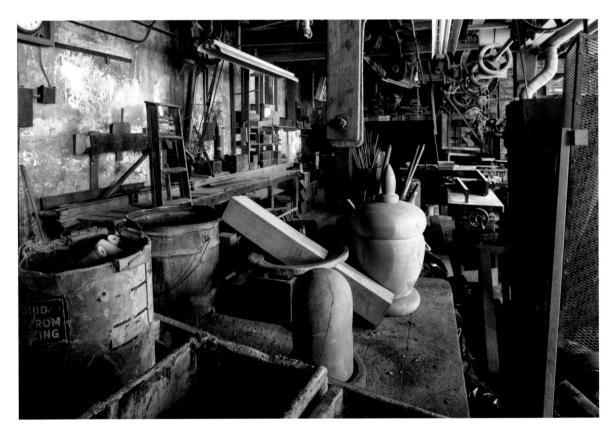

Plate 2.18
John Grass Wood Turning
Company, shop interior with finial,
2013 (HCF)

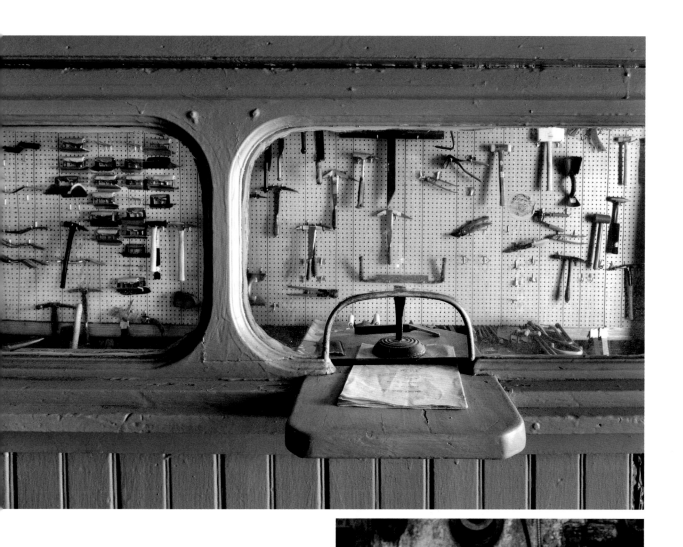

Plate 2.19
John Stortz and Son, pay window
with tool display, Race Street, 2016

Plate 2.20
John Stortz and Son, John Stortz
buffing a hammer, 2016

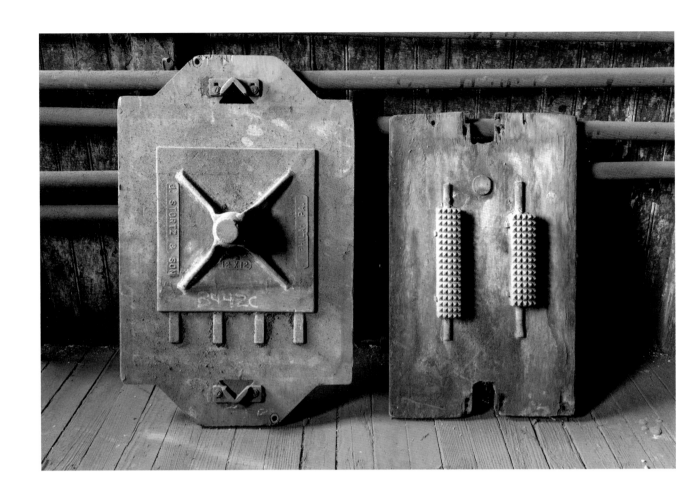

Plate 2.21
John Stortz and Son, patterns,
2016

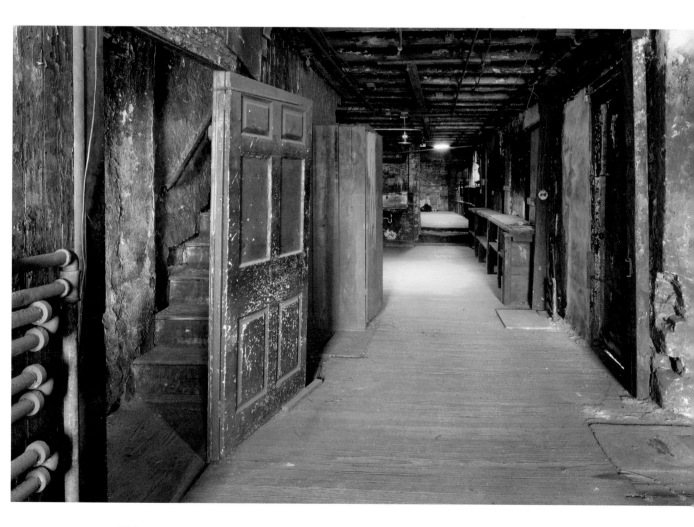

Plate 2.22
John Stortz and Son, second floor
shop area, 2016

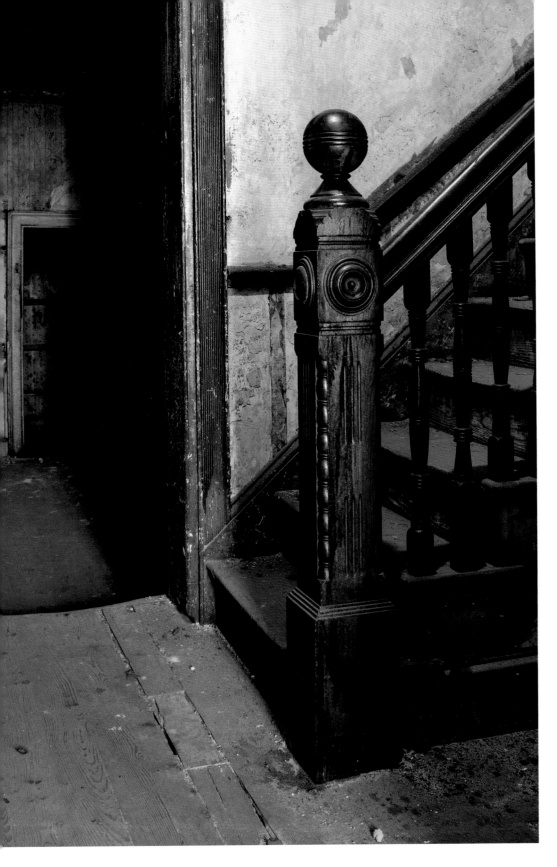

Plate 2.23
John Stortz and Son, stairway to
third floor lodgings, 2016

Plate 2.24 (top)
Wayne Mills, supervisor's office
on loom floor, Wayne Junction,
2016

Plate 2.25
Wayne Mills, thread for production
of warp, 2016

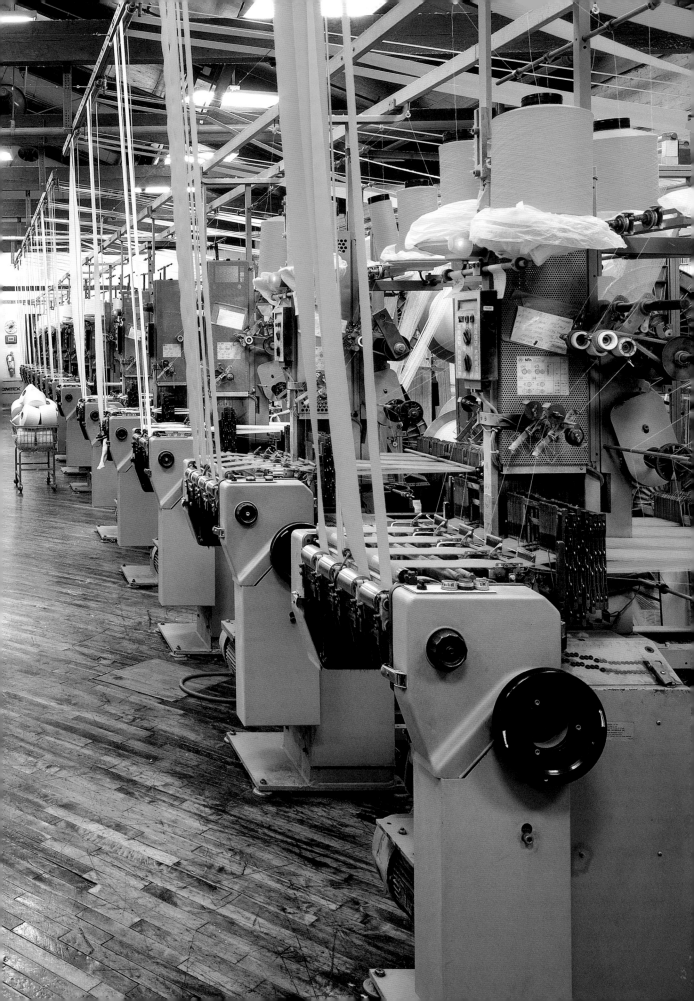

Plate 2.26 (previous spread)
Wayne Mills, loom floor,
2016

Plate 2.27
Wayne Mills, boxes of finished
narrow tape, 2016

Plate 2.28
Cunningham Piano Company,
view from the freight elevator,
Germantown, 2016

Plate 2.29
Cunningham Piano Company,
buffing a piano in the paint
shop, 2016

128

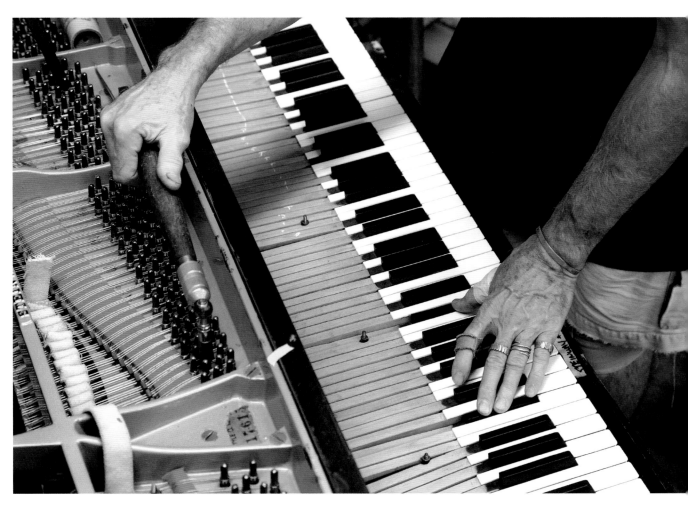

Plate 2.30
Cunningham Piano Company,
initial tuning, 2016

And yet as we travel through the Hidden City, often it seems that the past has arrived in the present whole, as if undigested by time. This is, in part, the optical illusion conjured by historic preservation, which privileges a building's elemental architectural form over the additions and alterations that follow. But landmark preservation does not account for the persistent consciousness of the past in the culture of Philadelphia. Only a small percentage of Philadelphia buildings are protected from removal or alteration by the city's historic preservation ordinance, despite the law's pioneering role in American urban development, and precious few of them are industrial workplaces. In a district like Germantown, which contains perhaps the single most comprehensive collection of American urban architecture, only a few buildings are legally protected. (A National Historic Landmark designation like the Wayne Junction National Industrial Historic District does not protect buildings from demolition or major alteration.) Instead, the past, embodied by a core Philadelphia material form, persists as a vital, yet unregulated, element of culture.

BAROQUE NATURE

When we envision a ruin, we tend to think of the abandoned physical remains of a building or a monument. Christopher Woodward's *In Ruins* broadens this idea by associating the physical decay of structures with the decline of civilizations. The ruin tends to be a useful metaphor. There are, he observes, many kinds of ruins—even fake ones erected by rich families for their own aesthetic pleasure. A lost world, with all its systems and strictures, can be a ruin, especially if there are buildings or landscapes associated with it. The ruins of the long-faded aristocratic milieu of Sicily, with its palazzos and rural estates, portrayed from a melancholic distance by Giuseppe di Lampedusa in his great novel *The Leopard* (1957), were an inspiration for Woodward's book.

As we give form to the Hidden City, we might consider the neighborhood ecology of work, social life, religion, and family, built during the long nineteenth century according to the political and economic circumstances of that time, as ruins. These invisible social, cultural, political, and economic structures, created and then abandoned by earlier generations of Philadelphians, are, like the Sicilian aristocracy of Lampedusa's ancestors, also ruins of a kind. In Philadelphia, as in Sicily, the invisible structures produced visible ones, actual physical ruins that simply get passed down generation by generation. Today we fish off the edge of a river pier conceived by a shipping magnate or a civil engineer as an essential node in a global shipping network that is long vanished. The pier is a ruin, but so is the nonmaterial shipping network that produced it. We walk streets cut out of woods, farm fields, wetlands, and meadows according to the

requirements of a seventeenth-century real estate scheme drawn up in London. To practice the circus arts, we climb onto a soaring trapeze installed on a "vacant" lot, once the site of a yarn mill and now filled with ascendant wildflowers. We take over brick and wooden beam and concrete lofts once filled with machines and envision a contemporary craftsman's revival, even if the craft is coffee roasting or distilling instead of carpet weaving or dyeing. Not only are our urban ruins living as raw material; we are also living in them.

The horizontal, family-owned industrial ecosystem of the nineteenth century produced a complex and intricate parochial life. Today, we inhabit the ruins of that world. Some four hundred churches and synagogues and eight hundred social clubs, societies, and political, philanthropic, and scholarly organizations filled the grid of Philadelphia, "far greater in number and better attended," wrote Thomas Eakins's biographer Sidney Kirkpatrick in 2006, "than would ever be the case in New York or Boston." This pattern began early in the eighteenth century with the Junto, a group of artisans led by Benjamin Franklin, who organized to make civic improvements and support each other's business endeavors. These early Philadelphians formed societies because, with the seat of empire across the Atlantic Ocean, no other authority was going to improve their quality of life. (In this sense Franklin was the architect of a very particular Philadelphia form of American republicanism.) Men of his generation organized to encourage scientific exploration, build libraries, fight fires, fund hospitals, open schools, support widows, light the streets, teach and display art, study medicine, chronicle the law, share literature, and regulate drinking. Immigrant groups formed patrimonial clubs; women taught textile trades. Later, in the mid-nineteenth century, bicyclists, singers, comics, rowers, baseball players, and political radicals built clubhouses and held public events. Some of these, like the Racquet Club, were for gentlemen only, and many, certainly, were off limits to women, blacks, Catholics, or Jews. Nathaniel Burt called the most elite of them either "F.B.F." (founded by Franklin) or "F. & O." (first and oldest). The American Philosophical Society was both. The clubs of "little Bohemia" on Camac Street, nestled into the nineteenth-century city's oldest-money neighborhood, added a tinge of blue blood to the enthusiasms of the age.

Just as clubs accumulated over several decades, they have disappeared slowly or hung on well beyond the demise of the social conditions that produced them. Some, particularly those promoting amateur endeavors in art and athletics, have survived. The Philadelphia Club, City Troop, Union League, Orpheus Club, Mask and Wig, Racquet Club, and Undine Barge Club endure in Center City, their clubhouses a mostly hidden element in the Hidden City. A clubhouse is often indistinguishable, but for a plaque on the door, from the row houses that surround it

Plate 2.31 (following spread)
Wagner Free Institute of Science,
exhibits on main floor, North
17th Street, 2015

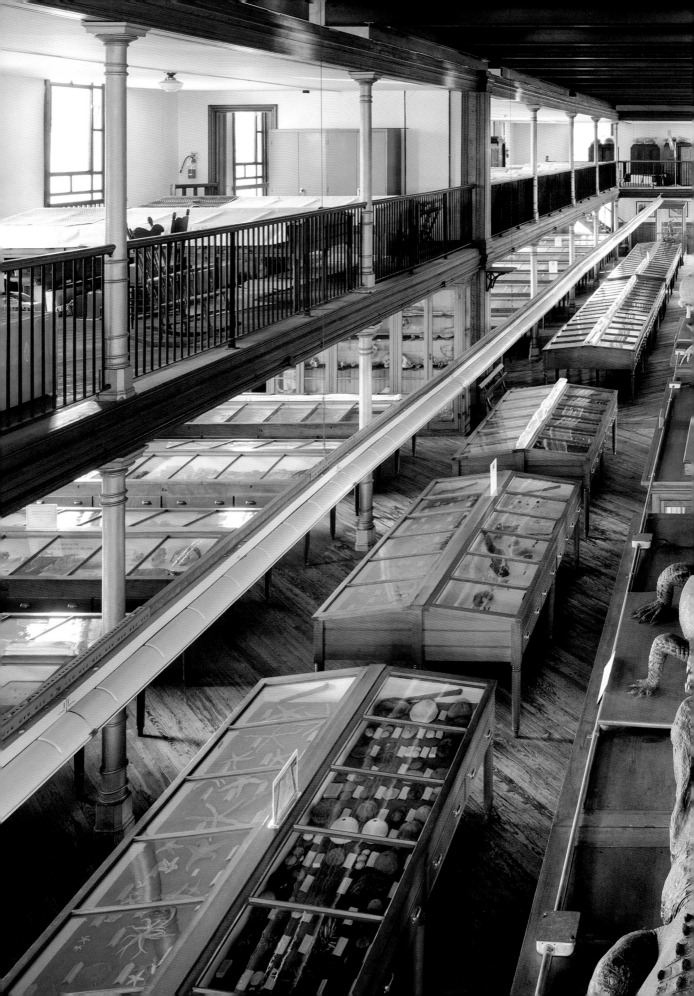

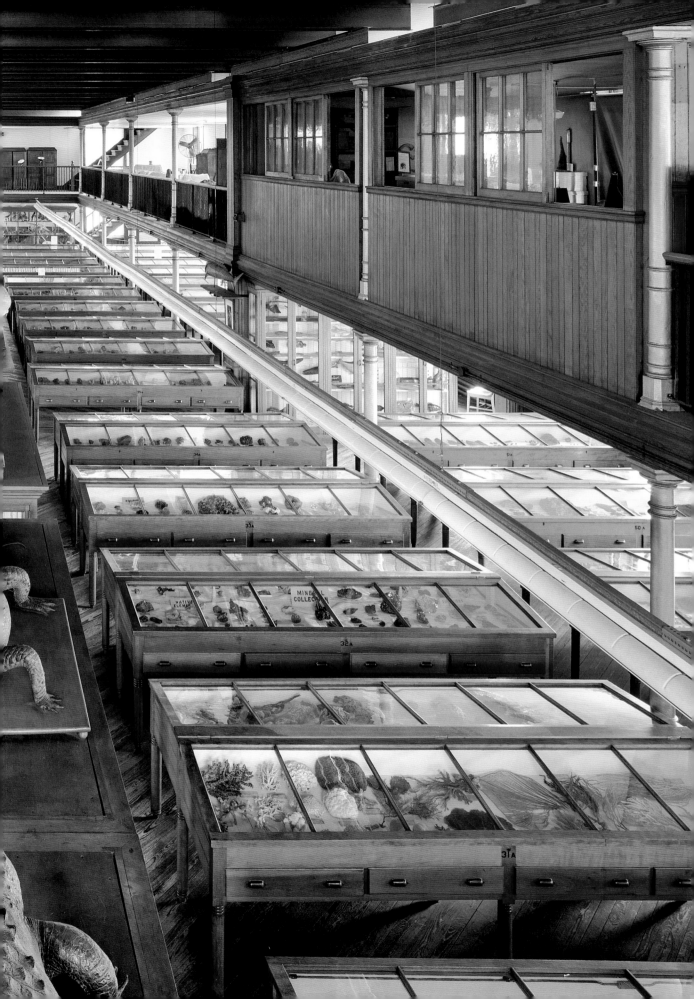

Plate 2.32
Wagner Free Institute of Science,
display cases with preserved
birds, 2015

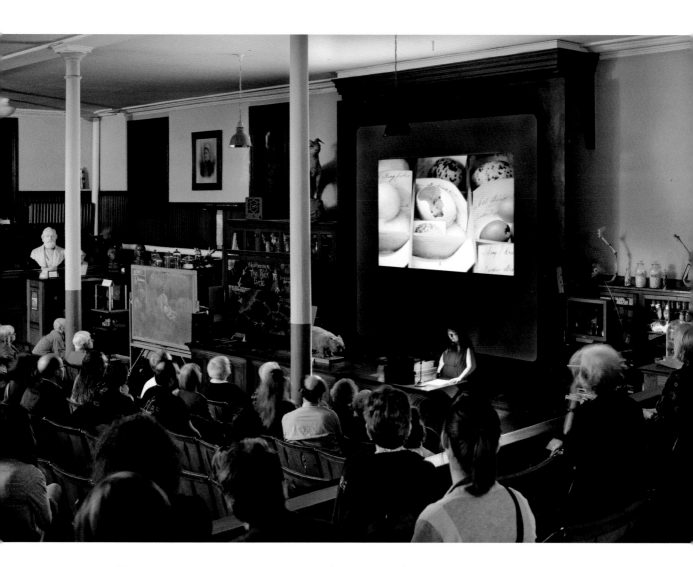

Plate 2.33
Wagner Free Institute of Science,
lecture hall, 2015

Plate 2.34 (following spread)
German Society of Pennsylvania,
library, Spring Garden Street,
2013 (HCF)

Plate 2.35
Undine Barge Club, locker room,
Boathouse Row, 2016

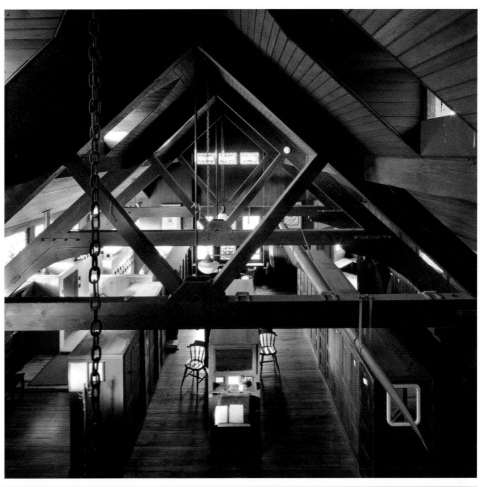

Plate 2.36 (top)
Undine Barge Club, locker room,
view from above, 2016

Plate 2.37
Undine Barge Club, locker room,
log book, 2016

Plate 2.38
Hawthorne Hall, posters and
broadsides, Lancaster Avenue,
2012

Plate 2.39
First Troop Armory, marble plaque
in entryway, 23rd Street, 2009
(HCF)

Plate 2.40 (top)
Racquet Club of Philadelphia,
portraits of club presidents,
16th Street, 2017

Plate 2.41
Racquet Club of Philadelphia,
court tennis player, 2016

UNITED STATES SQUASH RACQUET ASSOCIATION

INTER CITY TROPHY

BOSTON BALTIMORE PHILADELPHIA	1905	WON BY PHILADELPHIA
BOSTON BALTIMORE PHILADELPHIA	1908	WON BY PHILADELPHIA
BOSTON BALTIMORE PHILADELPHIA	1910	WON BY PHILADELPHIA
BOSTON BALTIMORE PHILADELPHIA	1911	WON BY PHILADELPHIA
BOSTON BALTIMORE PHILADELPHIA	1912	WON BY BOSTON

Plate 2.42
Racquet Club of Philadelphia,
intercity trophy plaque, 2017

Plate 2.43
Racquet Club of Philadelphia,
racquets court, 2016

(gentlemen's clubs, by definition, were understated). The professional advertising man's association, the Poor Richard Club, did not last, but the Pen and Pencil Club, a legendary F. & O. press association, lives on. Most Irish, German, Lithuanian, Polish, Jewish, Hungarian, Greek, Ukrainian, Russian, Sicilian, and African American associations have closed. Yet the German and Latvian societies remain open to members and the larger community; the Ruba Club (Russian-Ukrainian Beneficial Association), like others with large bars and stages, has attracted people seeking an "authentic" venue for parties and performances.

The close observer will notice these incremental characteristics in the Philadelphia streetscape. Unlike that of Chicago, for example, the Philadelphia scale of change, even in Center City, has been overwhelmingly accretive. In the 1960s, Philadelphia's implementation of Urban Renewal, particularly in Society Hill, followed this model. Contrary to nearly every other federally funded Urban Renewal effort to remove "slums" and "blight," Philadelphia's chief city planner, Edmund Bacon, sought to preserve elements of Society Hill's legacy streetscape and the finest buildings connected to the eighteenth and early nineteenth centuries, and fill in the rest with modern buildings that fit the scale and material palette of the old. This philosophy of urban change won the approval of the architecture critic and writer Jane Jacobs, author of *The Death and Life of Great American Cities*.

Bacon's strategy of privileging an intimate scale, at least during the Society Hill application of the federal Urban Renewal program, followed previous decisions to protect Philadelphia's architectural character, including the so-called gentlemen's agreement to build no taller than City Hall's tower. Cumulatively, the quiet urge of incremental change has left us with a city of extraordinary legibility. Standing on the street, those who learn to read the city discover an urban narrative as Philadelphia passes through time.

SACRED AND PLAIN

Father John Hughes, Irish immigrant priest of St. Mary's Church, Philadelphia's second Catholic church and first (unofficial) cathedral, was determined to get Catholics out of the shadows. Catholics could worship openly in Philadelphia, as William Penn had made his colony the first in the New World to codify religious freedom. Penn's legal vision, born of his own subjugation in England as an outspoken member of the Society of Friends, is part of an invisible skeletal armature of Philadelphia. From the start, religious practices proliferated, and by the Gilded Age there were churches, meetinghouses, and synagogues everywhere: more per capita than in any other great American city.

In 1831 Philadelphia Catholics still attended churches, like St. Mary's on 4th Street, that were meant to fit in with the city's Quaker plainness. (Perhaps only the Episcopalians violated the white-painted square box format.) Father Hughes, an aggressive man later known as "Dagger John," demanded something else. Martin Griffin's 1909 "History of the Church of Saint John the Evangelist, Philadelphia," sets forth Hughes's ambition. With Irish immigration soaring, it was time for a cathedral that would, he said, "shame the Quaker Meeting; make all the Bishops of all the churches jealous; cause those who gave nothing towards its erection to murmur at its costliness, and . . . expose the godly Presbyterian to the danger of squinting in his efforts to look the other way as he passes." Hughes built a soaring Gothic church, St. John the Evangelist, with two towers and the first American fresco, by Nicholas Monachesi. No longer hidden, Catholics would, from then on, imprint themselves indelibly on the city. Hughes's strategy begot an angry Nativist Protestant reaction in 1844, as riots exploded in May and July over the question of who should be allowed to call themselves Americans.

There were already one hundred thousand Catholics in Philadelphia and sixty churches, so Bishop Francis Kenrick had no fear of pushing back. In the year of the Bible Riots, as they were called, Kenrick purchased the northeast corner of 18th and Race Streets, on Logan Square, to build a cathedral. The Basilica of Saints Peter and Paul was designed by the architect Napoleon Eugene Charles Henry LeBrun. Other examples of grandeur followed: Gésu, St. Bonaventure, Visitation of the Blessed Virgin Mary, Our Mother of Sorrows, and Most Blessed Sacrament, among dozens and dozens, each following the city-within-the-city pattern of church, rectory, convent, and school.

Today, we live with the ruins of Father Hughes's promise to build enormous, ornate churches and parish communities. But parishes, as the story of Gésu attests, were not frozen. People moved out; others, often non-Catholics, moved in. African Americans, Catholic or not, were rarely accepted (most were directed to the "black parish," St. Peter Claver, at 12th and Lombard Streets). The swift decimation of neighborhood life brought on by the final collapse of the industrial economy in the 1970s drained the parish system. In the middle of the twentieth century, Most Blessed Sacrament at 56th Street and Chester Avenue was the largest parochial grammar school in the nation. In 1967, thirty-three hundred children were enrolled; by 1975, there were five hundred. The church, like dozens of others, was desanctified, sold, and nearly left to ruin. Independence Charter School West, which occupies the Most Blessed Sacrament campus, has begun to repair the church's dangerously leaky roof.

The undoing brings us to the original doing: the act of sanctifying a corner, a building, a lot. This act, in a city of religious freedom, is the moment at which an idea, the metaphysical, meets the material. Historians

Plate 2.44 (opposite)
Visitation of the Blessed Virgin Mary
Roman Catholic Church, view from the nave,
East Lehigh Avenue, 2015 (PSP)

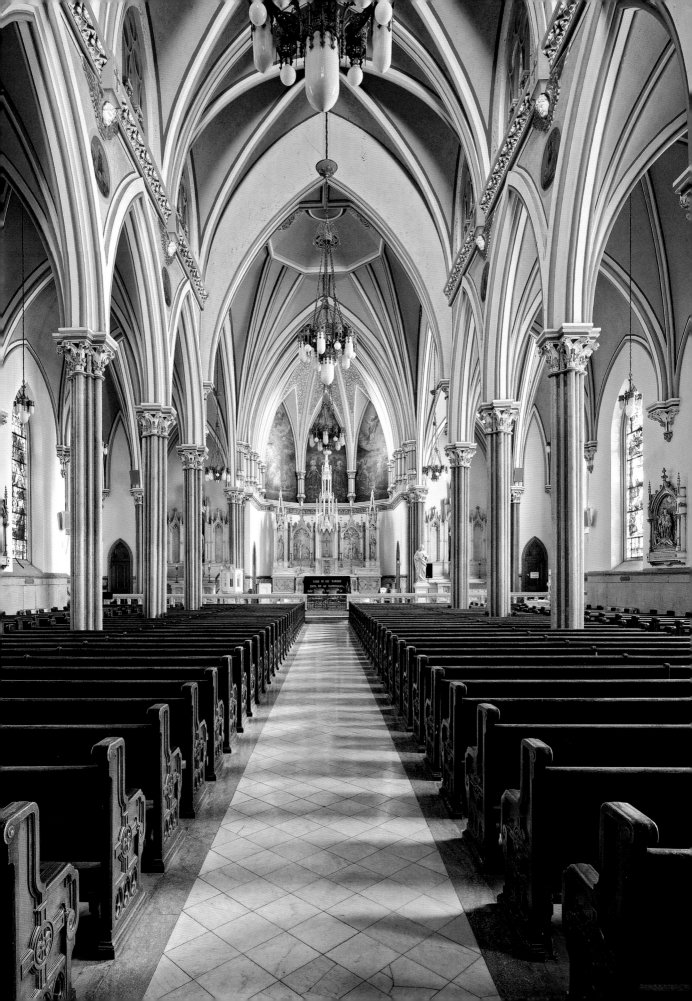

think that it was in 1787 that two former slaves, Absalom Jones and Richard Allen, organized a walkout from St. George's Methodist Church (a plain brick box, painted white inside), whose pastors forced black members to sit in a segregated section of the balcony. Frank Taylor made note of the occasion in his 1916 *Dictionary of Philadelphia*, the most significant reference to black life in the book. Under "Miscellaneous Firsts" and the year 1787, he wrote: "First Church in America owned by persons of color; St. Thomas' African Methodist Episcopal, Fourth and St. James Streets." Taylor was half accurate: 1787 is the year Richard Allen purchased the northeast corner of 6th and Lombard Streets, the first property in the United States to be owned by a black man. Allen decided to stay a Methodist, and Jones became Episcopalian. They went on to found the first black churches in America: St. Thomas Episcopal and Mother Bethel African Methodist Episcopal Church. Both opened in 1794 (money promised them by white allies was diverted to fighting a yellow fever epidemic in 1793). A statue of Allen at 6th and Lombard, installed in 2016, asserts the privilege, a century after Taylor's error, of getting the story right.

The sculpture of Allen, by Fern Cunningham-Terry, draws the pedestrian into a newly constructed brick box, a safe space, perhaps meant to be reminiscent of the first church on this site, an old blacksmith's shop that Allen hauled from blocks away. The present Mother Bethel, a stone fortress in French Renaissance style, opened in 1890. It sits, like a nesting doll, on the ruins of the blacksmith's shop, a second wooden church Allen built in 1805, and a third, of brick (at last), opened in 1841, exactly a decade after his death.

For forty-four years Allen had to defend the corner. When white Methodist officials insisted that St. George's owned the building and demanded the keys, Allen organized a sit-in (he perfected this tactic as well as the walkout) and refused to budge. The Pennsylvania Supreme Court ruled in his favor in 1817. Ever since, black churches—AME, Episcopal, Baptist, United Methodist—have assumed a role of utter and intense vigor in the lives of African American Philadelphians that is mostly invisible to everyone else. Shiloh Baptist Church, which took over the former Episcopal Church of the Holy Apostles in 1945 (and preserved much of the 1868 building), served a mid-twentieth-century congregation of three thousand. The congregation has dwindled as the neighborhood around the church has gentrified in recent years.

Rabbi Reuben Kanefsky, a Russian immigrant, chose a site exactly two blocks south of Mother Bethel when, in 1905, he moved his Hassidic congregation from a row house storefront on Passyunk Avenue to a grand Baroque Revival synagogue with two copper onion domes designed by Charles Bolton and John Dull. B'nai Reuben was the first synagogue building in Philadelphia's eastern European Jewish Quarter. Between 1882 and 1904, approximately sixty thousand Jewish immigrants from eastern Europe

Plate 2.45 (opposite)
Visitation of the Blessed Virgin
Mary Roman Catholic Church,
Christ reclining, 2015 (PSP)

Plate 2.46
Kensington Methodist Episcopal
Church, view from the balcony,
Marlborough Street, 2015 (PSP)

Plate 2.47
Kensington Methodist Episcopal
Church, choir music and
projector, 2015 (PSP)

Plate 2.48
Kensington Methodist Episcopal
Church, library and Sunday
school classroom, 2015 (PSP)

———

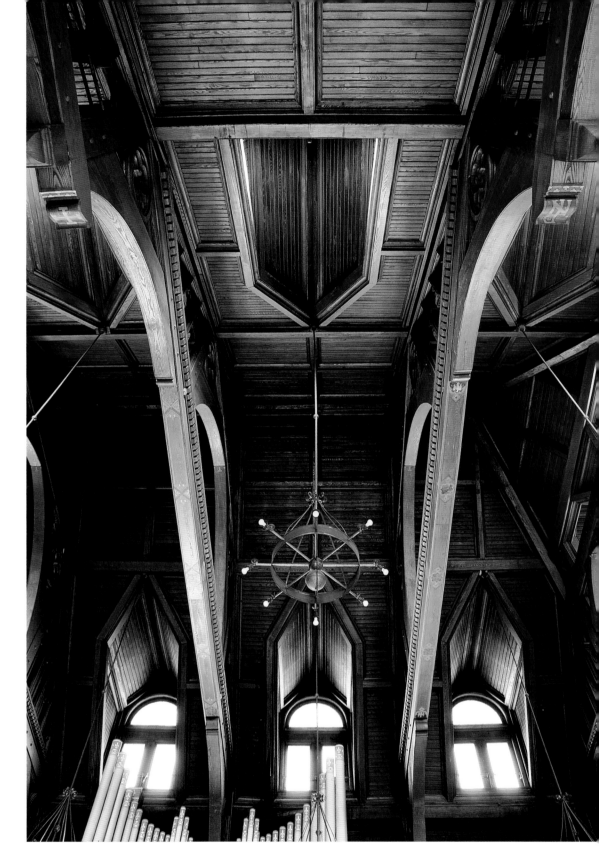

Plate 2.49
Shiloh Baptist Church, roof
structure of parish hall, Christian
Street, 2009 (HCF)

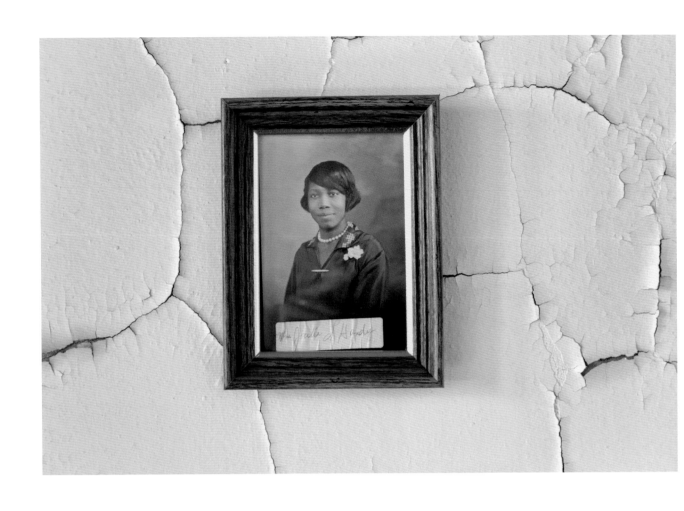

Plate 2.50
Shiloh Baptist Church, portrait
of parishioner, 2009 (HCF)

Plate 2.51
Shiloh Baptist Church, detail
of ornate brick work in parish hall,
2009 (HCF)

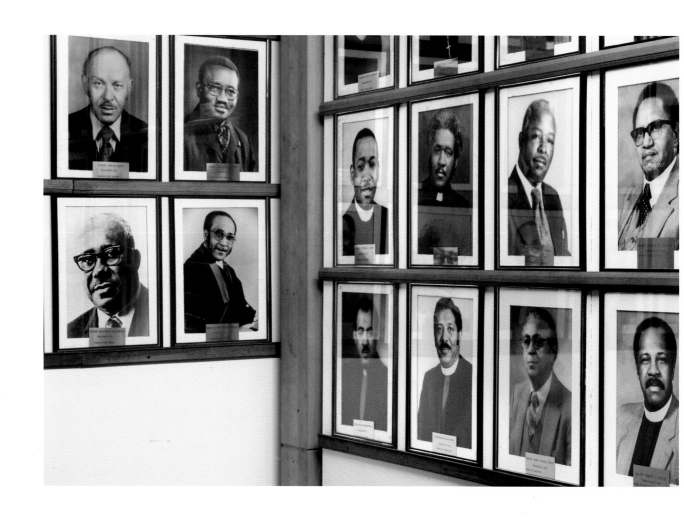

Plate 2.52
Mother Bethel African Methodist
Episcopal Church, portraits of former
pastors, 6th Street, 2013 (HCF)

landed at Washington Avenue Pier. They settled in the neighborhood surrounding South Street and founded charitable organizations, worker cooperatives, libraries, schools, syndicates, improvement associations, burial societies, and synagogues. Other, wealthier immigrant congregations purchased old churches as the raw material for their sacred lives, adapting them for Jewish worship, as if producing a palimpsest of brick, plaster, and paint. The founders of Kesher Israel purchased the First Universalist Church on Lombard Street. The group of Russian Jews who formed B'nai Abraham purchased and adapted the 1820 First Colored Wesley Methodist Church, adjacent to Mother Bethel. First Colored Wesley was itself a product of a splinter and a walkout—from Richard Allen's church.

Following the old Quaker-influenced Philadelphia tradition of religious groups keeping a low profile and fitting in, most new synagogue groups took over row houses and storefronts and adapted them for worship. Congregation Shivtei Yeshuron Ezras Israel was one of the earliest synagogues to form a minyan and hold services. In 1909 the congregation moved into a row house storefront at 4th and Emily Streets. More than a century later, it is the last of the dozens of storefront synagogues of South Philadelphia.

Jews began abandoning the Jewish Quarter in the 1920s. B'nai Reuben closed in 1956, leaving the Baroque synagogue, with its engraved stars of David and Hebrew inscription above the door, in the path of the planned Crosstown Expressway. A powerful coalition of advocate city planners and architects, affordable housing activists, second- and third-generation descendants of Jewish and Polish immigrants, and hippies launched a movement against the highway. The Crosstown plan was finally scrapped in the 1980s. Inhabiting the ruins, antiques dealers took over B'nai Reuben's first floor and basement and hung a sign reading "Antiquarians Delight" above the door, layered over the Hebrew inscription. In 2014 a real estate developer who had purchased the building to convert it into apartments removed the sign, revealing the detailed inscription for the first time in decades. Months later, an untrained mason hired by the developer took a power chisel to the Hebrew letters and the stars of David that flanked the entrance at the first and second levels. He mashed concrete into the opening and, in place of the stars, inserted a decorative form that resembles a Greek cross (the developer is an immigrant from Greece). He tacked on a plaque recalling the history of B'nai Reuben, an empty gesture after erasing a legible layer of city life.

Plate 2.53 (following spread)
Congregation Shivtei Yeshuron
Ezras Israel, front elevation,
South 4th Street, 2013 (HCF)

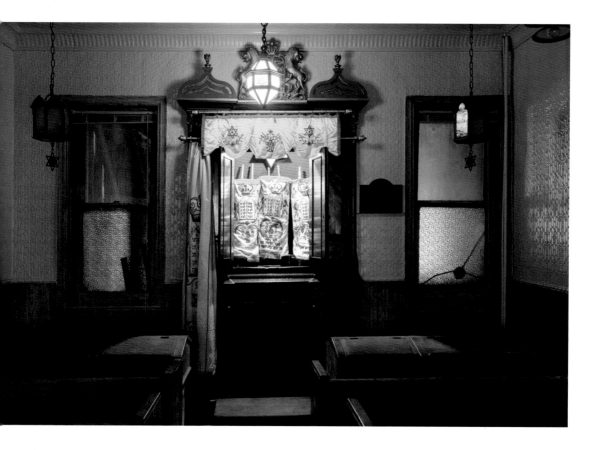

Plate 2.54
Congregation Shivtei Yeshuron
Ezras Israel, Ark with Torahs,
2013 (HCF)

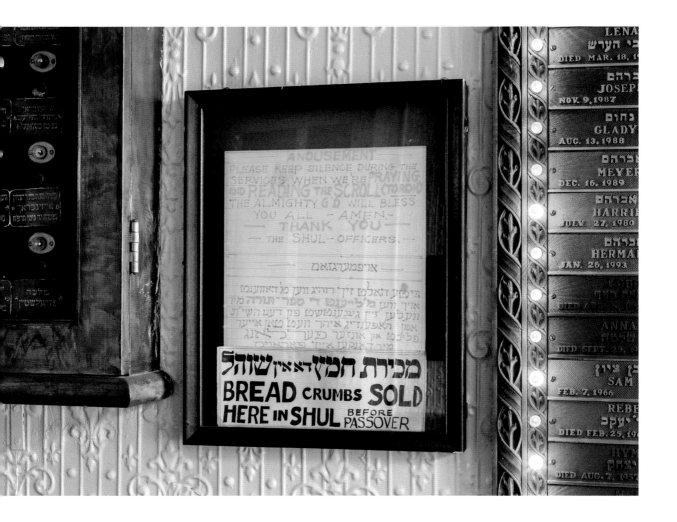

Plate 2.55
Congregation Shivtei Yeshuron
Ezras Israel, announcement sign,
2013 (HCF)

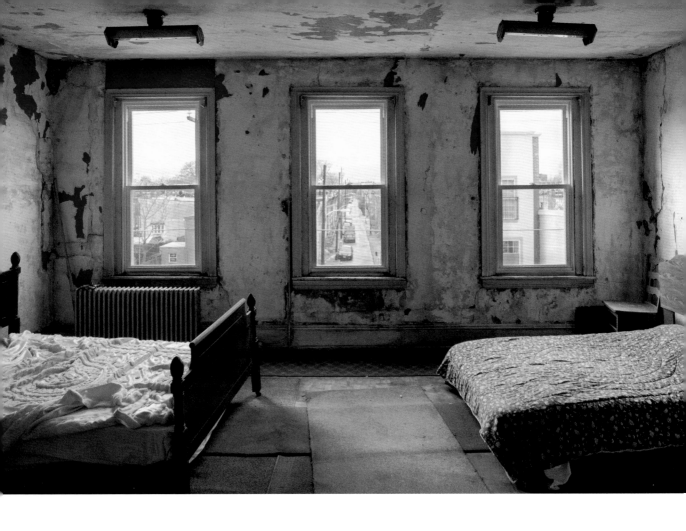

Plate 2.56
Congregation Shivtei Yeshuron
Ezras Israel, second floor, beds for
rabbis, 2013 (HCF)

In 1854 the twenty-nine distinct political districts that made up Philadelphia County were incorporated into the City of Philadelphia. To compensate for the loss of local control, the new city bestowed civic investments on the formerly independent districts. Thanks to an example of baroque political dealing, Germantown received a new town hall despite no longer having a town government. Town Hall was built in the backward-gazing Greek Revival style by the architect of Philadelphia's Roman Catholic Basilica of Saints Peter and Paul, the baroquely named Napoleon Eugene Charles Henry LeBrun.

The unified municipal police department set up a station in Town Hall and maintained it until the Civil War, when the building was used as a hospital. Later it hosted traveling shows and political meetings. By 1920, fully a century after the Greek Revival took hold in the city, Germantown Town Hall was falling down, and civic leaders had to decide whether or not to replace the town hall of a town that hadn't existed since 1854.

By the time City Architect John Penn Brock Sinkler began designing a new Town Hall in 1922, another classical revival in architecture had begun. On the Benjamin Franklin Parkway, monumental examples of the Classical Revival—the Free Library and the Philadelphia Museum of Art—were under construction. Sinkler, probably named for the grandson of William Penn, a poet and the last proprietary governor of Pennsylvania, naturally set his eyes on the 1832 Greek Revival Merchants' Exchange at 2nd and Walnut Streets, directly across the street from the Slate Roof House, said to be where William Penn stayed while visiting his city in 1701. Following the baroque logic of Philadelphia's civic mind, Sinkler built a copy of the Merchants' Exchange at Germantown and Haines, with a rotunda to memorialize Germantown residents who had died in the Great War.

As if repeating the same phrases but with different intonations, Sinkler tucked the clock and bell from LeBrun's original Greek Revival Town Hall into the roof tower of his copy of the Merchants' Exchange, which was itself William Strickland's copy of the Choragic Monument of Lysicrates. The cloistered intricacy of this approach to civic development, provincial and drowsy, protected Philadelphia from seismic change. By the time of the second Hidden City Festival, in 2013, the clock tower was crumbling and filled with pigeon scat. Even the decay has the essentially baroque quality of wealth decomposing. The explorer in the Hidden City, standing outside Germantown Town Hall, might notice a decadent air. The building's last tenant, the Mayor's Office of Community Services, has closed, leaving the office as it was on the last day of operation. Posters showing Philadelphia Eagles players of the 1990s are still tacked to the wall, and bureaucratic maps catch the dulcet light through hundred-year-old glass. Time is suspended here, as it was for Christopher Woodward, breathing in

HOLD SACRED
THEIR IDEALS
OF HONOR
JUSTICE
AND RIGHTEOUSNESS

Plate 2.57
Germantown Town Hall, World
War I monument in rotunda,
Germantown Avenue, 2013 (HCF)

Plate 2.58
Germantown Town Hall,
doorway to Mayor's Action Center,
2013 (HCF)

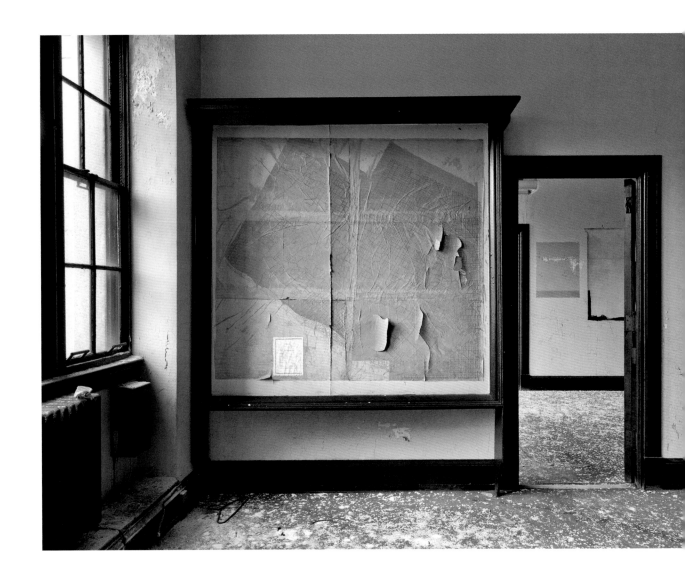

Plate 2.59
Germantown Town Hall,
office with map of Northwest
Philadelphia, 2013 (HCF)

the "decaying embrace" of the old bridge on an abandoned English estate. Like the bridge, Germantown Town Hall may never be used again. It was, after all, built without clear practical purpose as a kind of false ruin. Left alone to crumble, as it has been since the 2013 Festival, its only use may be to reveal time.

Where does all this time collect, ultimately? In a suitably elaborate mass of 88 million bricks and 200 works of sculpture, at the center of the city's original grid: City Hall. The executive, legislative, and judicial branches of municipal government share this civic castle of 662 rooms covering 14.5 acres, organized around a courtyard, watched over by a 35-foot statue of the city's founder, William Penn, atop a tower of medieval proportions. Ceremonial rooms remind the visitor of the bureaucratic grandeur of Florence or Venice. Behind wooden doors numbered in gold leaf, in the highest reaches near the base of the tower, court records, deeds, titles, wills, audits, tax bills, and reports on the function of prisons, street pavers, trash collectors, bridge repair, and firefighting collect—Philadelphia gathering endlessly upon itself.

Though City Hall wasn't completed until 1901, workers started clearing the site at Centre Square in 1871, about the time engineers began writing the specifications for the main buildings of the Centennial World's Fair of 1876. Those buildings, the engineers decided, would be made of iron and steel; though massive—the Main Hall was the world's largest structure at the time of construction—they could be dismantled when the fair was over and recycled. City Hall, however, would be permanent, like a castle. This was the vision of the architect, the Scots-Irish Presbyterian John McArthur Jr. Furthermore, it would borrow the form, position, visual scale, and detailing of the Hôtel de Ville of Paris, built in 1357, and refine it with detailing based on the French Second Empire style, favored for American civic buildings of the time.

Following the French tradition of placing monumental buildings— such as the Palais Garnier in Paris—in the center of a broad axis, McArthur designed City Hall to sit in the center of Centre Square, not facing the square, thus forcing everyone to acknowledge and encounter it. This was a bold gesture, post–Civil War Philadelphia claiming its urban eminence, but also a human one. The citizen did not have to climb a fortress of stairs to get inside. A couple could walk right into the Marriage License Bureau and start a new life. Or, bundled against the cold, they could stand in the courtyard or the arcade opposite, between the castle of City Hall and the castle of Broad Street Station, and campaign for workers' rights or gender equality or political reform. It was the people's castle.

But then ambition met practical reality. Eventually, the Organization had its way. With its two hundred sculptures and commemorative plaques and memorials already blackening from soot during the thirty years of construction, City Hall came to embody the lumbering, corrupted, baroque

Plate 2.6o (following spread)
City Hall, Council Caucus
Room, 2016

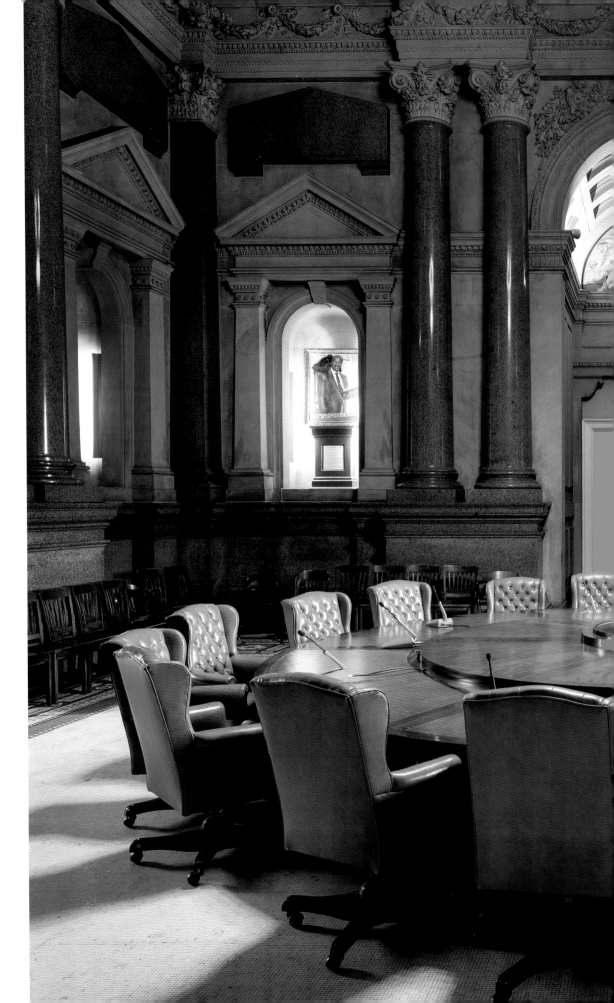

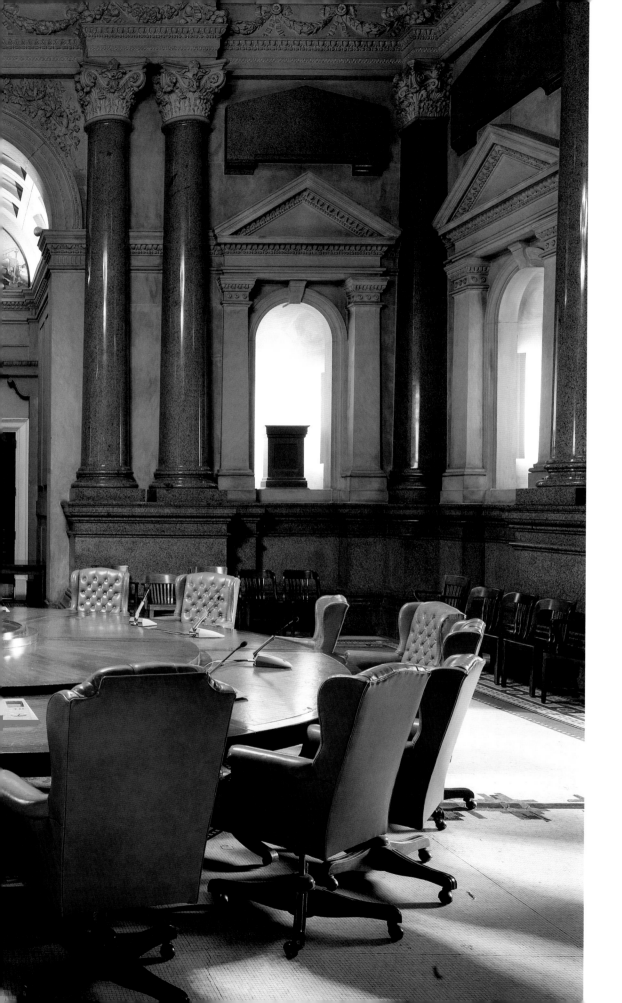

Plate 2.61
City Hall, office of Councilwoman
Jannie Blackwell, 2016

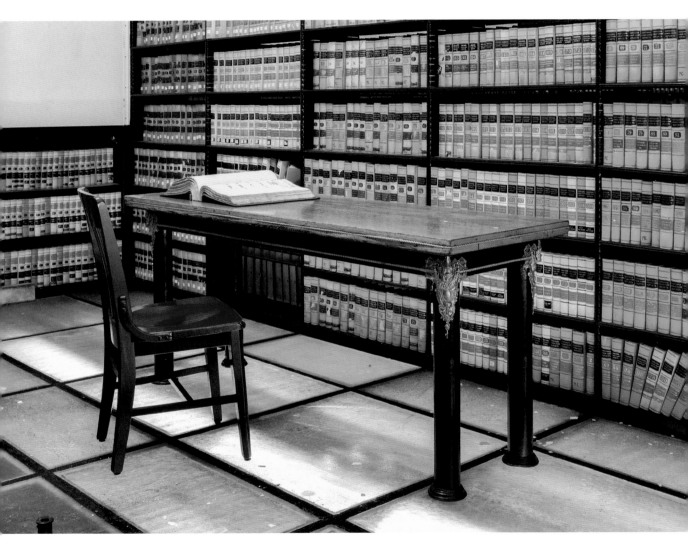

Plate 2.62
City Hall, Law Library, 2016

Plate 2.63
City Hall, inventory ledgers in
basement vault, 2016

machine. The Organization, wrote Nathaniel Burt, operated with "craggy complacency" and seemed to resist the national civil service reforms of 1915 and the emergence of the New Deal in the 1930s. A second civil service reform, at the start of the 1950s, marked its end, but by the time Burt began poking around the Hidden City, a new machine was elbowing in to take its place. This one was Democratic but ultimately not all that different in its emphasis on relationships and ward-level transactions.

Frank Taylor lamented the way office towers had "shut in and dwarfed" City Hall. Yet in a sketch he called "At Six O'Clock," he appeared willing to show how well City Hall wore the patina of time. With surrounding "office buildings aglow with the lights of a thousand windows" (as Taylor notes in the sketch's caption) and steam rising from the Pennsylvania Railroad Station across the way, City Hall, its tower clock lit like a beacon, took on the elegance of the sleek and slender age. The urban landscape is the form of time trapped and time in motion. At Germantown Town Hall, a decaying ruin, time is suspended. At City Hall, still actively collecting the layers of the people of Philadelphia, time is fluid. Both kinds of places, indeed, condition our experience of the Hidden City.

LIST OF PLATES

Part 1

Part 2

Plate 2.44
Visitation of the Blessed Virgin
Mary Roman Catholic Church,
view from the nave, East
Lehigh Avenue, 2015 (PSP)
Plate 2.45
Visitation of the Blessed Virgin
Mary Roman Catholic Church,
Christ reclining, 2015 (PSP)
Plate 2.46
Kensington Methodist
Episcopal Church, view from
the balcony, Marlborough
Street, 2015 (PSP)
Plate 2.47
Kensington Methodist
Episcopal Church, choir music
and projector, 2015 (PSP)
Plate 2.48
Kensington Methodist
Episcopal Church, library and
Sunday school classroom,
2015 (PSP)
Plate 2.49
Shiloh Baptist Church, roof
structure of parish hall,
Christian Street, 2009 (HCF)
Plate 2.50
Shiloh Baptist Church, portrait
of parishioner, 2009 (HCF)
Plate 2.51
Shiloh Baptist Church, detail
of ornate brick work in parish
hall, 2009 (HCF)
Plate 2.52
Mother Bethel African
Methodist Episcopal Church,
portraits of former pastors,
6th Street, 2013 (HCF)
Plate 2.53
Congregation Shivtei
Yeshuron Ezras Israel, front
elevation, South 4th Street,
2013 (HCF)
Plate 2.54
Congregation Shivtei
Yeshuron Ezras Israel, Ark with
Torahs, 2013 (HCF)

Plate 2.55
Congregation Shivtei
Yeshuron Ezras Israel,
announcement sign, 2013
(HCF)
Plate 2.56
Congregation Shivtei
Yeshuron Ezras Israel, second
floor, beds for rabbis, 2013
(HCF)
Plate 2.57
Germantown Town Hall,
World War I monument in
rotunda, Germantown Avenue,
2013 (HCF)
Plate 2.58
Germantown Town Hall,
doorway to Mayor's Action
Center, 2013 (HCF)
Plate 2.59
Germantown Town Hall,
office with map of Northwest
Philadelphia, 2013 (HCF)
Plate 2.60
City Hall, Council Caucus
Room, 2016
Plate 2.61
City Hall, office of Council-
woman Jannie Blackwell, 2016
Plate 2.62
City Hall, Law Library, 2016
Plate 2.63
City Hall, inventory ledgers in
basement vault, 2016

As the founder of Hidden City Philadelphia, Thaddeus Squire gave Philadelphians a new way to relate to their city—as a place of exploration, discovery, and possibility. Thaddeus commissioned Joe Elliott to photograph the nine sites chosen for the first Hidden City Festival in 2009 and hired Pete Woodall and Nathaniel Popkin to launch a web magazine, the *Hidden City Daily*, to transform the festival experience into journalism. He showed exceptional generosity in giving us the freedom to elaborate on his initial ideas. *Philadelphia: Finding the Hidden City* would not exist without Thaddeus's vision.

This book owes a great deal to the writers and editors we've worked with on the *Hidden City Daily*, particularly our co-editors, Michael Bixler and Bradley Maule, and diligent and committed contributors Dennis Carlisle and Rachel Hildebrandt. Original Hidden City Philadelphia board members Bob Beatty, Conor Corcoran, Justin Detwiler, Christopher Plant, and Andre Stefano supported the work that went into this book. After initiating Hidden City Philadelphia, Thaddeus founded the co-working/management agency CultureWorks Greater Philadelphia, whose expert staff has helped us continue this work. We owe finance director Ellen Snyder our particular gratitude.

We thank Catherine Lavoie, the chief of the Historic American Buildings Survey (HABS) at the National Park Service. Under Catherine's direction HABS conducted the Acres of Diamonds project in 2002. HABS commissioned Joe to do the photographic documentation of each site, including the Divine Lorraine Hotel, the Bible Institute, the Wagner Free Institute of Science, and Founders Hall of Girard College. Later, in 2005, Joe worked again with HABS on the Tacony neighborhood, including Disston Precision. These projects were the source of the black-and-white images in this volume and Joe's introduction to the deep and wonderful architectural fabric of Philadelphia.

Our work on this book was made possible by the archival resources of the Athenaeum of Philadelphia, where, as writer-in-residence, Nathaniel drafted much of the text.

Research intern Maia Reumann-Moore and Joel Naiman and Carolyn Zemanian, students in the University of Pennsylvania graduate program in historic preservation, assembled briefs on the buildings we cover in the book.

Pete and Nathaniel developed a deep curiosity about Philadelphia prior to our involvement with Hidden City Philadelphia, so we must mention some early partners in exploration: Seth Donkochik, Peter Siskind, and Harmon Zuckerman. Nathaniel thanks Andrew Ferrett, Shan Holt, Sam Katz, and Katie Oxx, collaborators on *Philadelphia: The Great Experiment*, for a decade of conversation on Philadelphia and its history.

Former Temple University Press editor Micah Kleit approached us about writing this book. His enthusiasm has carried over to our wonderful editor Sara Cohen and the press's terrific staff. The exceptional graphic designer Michael Dyer transformed the text and photographs into a single coherent work.

Steve Block and Betty Morgan, of the Kenneth Paul Block Foundation, provided the generous financial support that made this book possible. Muhlenberg College provided research funding that allowed Joe to devote full-time work to the project and supported student research assistant Avery Brunkus's initial editing of the images.

We thank all the people who granted us access to the sites discussed and photographed in this book, including Lynn Buggage, Church of the Advocate; former City Hall tour and Visitor Center director Greta Greenberger; Ring Lardner, Disston Precision Inc.; Curt Mangel and Matthew Taft, staff of Macy's, who manage the Wanamaker Organ; Ms. Yvette, Peace Mission Movement; Dr. Leonard Primiano, Cabrini College; John C. Stortz, John Stortz and Son; Robert Pierce, Metropolitan Regional Council of Carpenters, owner of John Grass Wood Turning Company; Dennis Dunning and Walt Masny, Exelon Corporation, owner of Richmond Generating Station; Drew Brown and Adam Levine, Philadelphia Water Department; People's Emergency Center, especially former vice president Kira Strong; Pete Kelly, Globe Dye Works; Derik Comali, Racquet Club of Philadelphia; Pastor Dave Ryan, Kensington Methodist Episcopal Church; Father John Olenick, Visitation of the Blessed Virgin Mary Roman Catholic Church; Joel Spivak, Shivtei Yeshuron Synagogue; Father Alexander Masluk, Our Mother of Sorrows Roman Catholic Church; John Herzins, City of Philadelphia; the Reverend Mark Hatcher, Holy Ghost Headquarters Revival Center, Metropolitan Opera House; Rahim Islam and Patricia Wilson Aden, Universal Companies, Royal Theater; Claudine Evans and former archivist Elizabeth Laurent, Girard College; Susan Glassman, Wagner Free Institute of Science; Bill Conners, Church of the Gesú, St. Joseph's Preparatory School; Fran O'Brien, Delaware River Port Authority; Shawn Hawes, Philadelphia Department of Prisons; Martin Hellman, president of Wayne Mills; Rich Galassini and Tim Oliver, owners of Cunningham Piano Company; Joey Hoepp and Butch Parillo, Undine Barge Club; Bill ("Bucky") Buchanan, First Troop Philadelphia City Cavalry; Anton Michels and Hardy von Auenmueller, German Society of Pennsylvania; the Reverend Edward Sparkman, Shiloh Baptist Church; and the Reverend Mark Kelly Tyler, Mother Bethel African Methodist Episcopal Church.

Finally, we thank our respective partners, who have been steadfast in their support while we chipped away at this book: Betsy Elliott (Joe), Rona Buchalter (Nathaniel), and Rachel Dobkin (Pete).

**Benjamin Franklin
Bridge**
(Plate 1.38)
1926
Paul Philippe Cret, architect;
Ralph Modjeski, engineer

Church of the Advocate
(Plates 1.16, 1.17, 1.18)
1801–1819 Diamond Street
1897
Charles M. Burns, architect

Church of the Gesú
(Plates 1.25, 1.26, 1.27)
18th and Stiles Streets
1888
Edwin Forrest Durang, architect

**Circle Mission Bible
Institute**
(Plate 1.9)
764–772 S. Broad Street
1897

City Hall
(Plates I.2, I.5, 2.60, 2.61,
2.62, 2.63)
Broad and Market Streets
1901
John McArthur Jr., architect,
with Thomas U. Walter,
and Alexander Milne Calder,
sculptor

**Congregation Shivtei
Yeshuron Ezras Israel**
(Plates 2.53, 2.54, 2.55, 2.56)
2015 S. 4th Street
1909

**Cunningham Piano
Company**
(Plates 2.28, 2.29, 2.30)
26 E. Coulter Street
19th century

**Delaware River bank at
Betsy Ross Bridge**
(Plates 1.31, 1.32)
1976
Delaware River Port Authority

Disston Saw Works
(Plates 2.12, 2.13, 2.14,
2.15, 2.16)
6700–6800 State Road and
5100–5200 Unruh Street
1936
Disston Saw Works

Divine Lorraine Hotel
(Plates 1.11, 1.12, 1.13)
699 N. Broad Street
1893
Willis G. Hale, architect

**Franklin Square Subway
Station**
(Plates 1.39, 1.40)
6th and Race Streets
1936
Philadelphia Rapid Transit
Company

**German Society of
Pennsylvania**
(Plate 2.34)
611 Spring Garden Street
1888
G. Knoche, architect

Germantown Town Hall
(Plates I.7, 2.57, 2.58,
2.59)
5928–5930 Germantown
Avenue
1923
John Penn Brock Sinkler,
architect

Girard College Chapel
(Plate 1.24)
2101 S. College Avenue
1931
Thomas and Martin, architects

**Girard College Founder's
Hall**
(Plates 1.19, 1.20, 1.21)
2101 S. College Avenue
1848
Thomas U. Walter, architect

**Girard College High
School**
(Plate 1.22)
2101 S. College Avenue
1921
John Torrey Windrim, architect

Girard College Library
(Plate 1.23)
2101 S. College Avenue
1931
Edward L. Tilton, architect

Globe Dye Works
(Plates I.6, 2.9, 2.10, 2.11)
4500 Worth Street
1867, additions 1871, 1873,
1874, 1880, 1885, and 1891
(renovation beginning 2008)
DIGSAU, renovation
architect master plan

Hawthorne Hall
(Plate 2.38)
3849 Lancaster Avenue
1895
Arthur Wright and Adolphus
Prentzel, developers

Holmesburg Prison
(Plates 2.4, 2.5, 2.6, 2.7, 2.8)
8215 Torresdale Avenue
1886
Wilson Brothers, engineers

**John Grass Wood Turning
Company**
(Plates 2.17, 2.18)
146 N. 2nd Street
19th century

John Stortz and Son
(Plates 2.19, 2.20, 2.21, 2.22,
2.23)
210 Vine Street
1853

**Kensington Methodist
Episcopal Church**
(Plates 2.46, 2.47, 2.48)
300–304 Richmond Street
1853

Metropolitan Opera House
(Plate I.1)
858 N. Broad Street
1908
William H. McElfatrick, architect

Mill Creek Sewer
(Plates 1.28, 1.29)
late 19th century
Philadelphia Water Department

Mother Bethel African Methodist Episcopal Church
(Plate 2.52)
419–423 S. 6th Street
1890
Hazelhurst and Huckel, architects

Our Mother of Sorrows Roman Catholic Church
(Plate I.3)
4800–4814 Lancaster Avenue
1867
Edwin Forrest Durang, architect

Racquet Club of Philadelphia
(Plates 2.40, 2.41, 2.42, 2.43)
213–225 S. 16th Street
1905
Horace Trumbauer, architect

Reading Railroad City Branch
(Plates 1.33, 1.34, 1.35, 1.36)
1832 (original), 1898
Reading Company, City of Philadelphia

Reading Railroad Viaduct
(Plate 1.37)
1893
Reading Company

Richmond Generating Station
(Plates 2.1, 2.2, 2.3)
N. Delaware Avenue and Lewis Street
1925
John T. Windrim, architect

Royal Theater
(Plates 1.6, 1.7, 1.8)
1524–1534 South Street
1920
Frank Hahn, architect

Shiloh Baptist Church
(Plates 2.49, 2.50, 2.51)
2030–2040 Christian Street
1870, alterations 1873, 1890, 1902, 1910
George W. Hewitt (Frazer, Furness and Hewitt), architect

Undine Barge Club
(Plates 2.35, 2.36, 2.37)
13 Boathouse Row
1883
Furness and Evans, architects

Unity Mission Church
(Plates 1.10, 1.14, 1.15)
1530 N. 16th Street
1883
Edwin Forrest Durang, architect

Visitation of the Blessed Virgin Mary Roman Catholic Church
(Plates 2.44, 2.45)
2625 B Street
1879, alterations 1915
Edwin Forrest Durang, architect

Wagner Free Institute of Science
(Plates 2.31, 2.32, 2.33)
1700 W. Montgomery Avenue
1859, alterations 1895, 1903
John McArthur Jr., architect

Wanamaker Department Store
(Plates 1.1, 1.2, 1.3, 1.4, 1.5)
1300 Market Street
1911
Daniel Burnham, architect

Water Filtration Chamber
(Plates I.4, 1.30)
1903
Philadelphia Water Department

Wayne Mills
(Plates 2.24, 2.25, 2.26, 2.27)
130 Berkley Street
1885
New Glen Echo Mills, original owner

Burt, Nathaniel. *The Perennial Philadelphians: The Anatomy of an American Aristocracy*. New York: Little, Brown, 1963.

Christopher, Matthew. *Abandoned America: The Age of Consequences*. Versailles: JonGlez Publishing, 2014.

———. *Abandoned America: Dismantling the Dream*. London: Carpet Bombing Culture, 2016.

Davis, Mike. *City of Quartz: Excavating the Future in Los Angeles*. New York: Verso, 1990.

Feldman, Vincent. *City Abandoned: Charting the Loss of Civic Institutions in Philadelphia*. Philadelphia: Paul Dry Books, 2014.

Griffin, Martin. "History of the Church of Saint John the Evangelist, Philadelphia." Records of the American Catholic Historical Society of Philadelphia 20 (1909).

Gunther, John. *Inside U.S.A.* New York: Harper and Brothers, 1947.

Keels, Thomas. *Sesqui! Greed, Graft, and the Forgotten World's Fair of 1926*. Philadelphia: Temple University Press, 2017.

Kirkpatrick, Sidney. *The Revenge of Thomas Eakins*. New Haven, CT: Yale University Press, 2006.

Koolhaas, Rem. *Delirious New York: A Retroactive Manifesto for Manhattan*. New York: Monacelli Press, 1994.

McKee, Guian. *The Problem of Jobs: Liberalism, Race, and Deindustrialization in Philadelphia*. Chicago: University of Chicago Press, 2008.

Moore, Andrew. *Detroit Disassembled*. Akron, OH: Damiani/Akron Art Museum, 2010.

Page, Max. *The Creative Destruction of Manhattan, 1900–1940*. Chicago: University of Chicago Press, 1999.

Peterson, Charles. "Ante Bellum Skyscraper." *Journal of the Society of Architectural Historians* 9, no. 3 (October 1950).

Primiano, Leonard Norman. "'And as we dine. We sing and praise God': Father and Mother Divine's Theologies of Food." In *Religion, Food, and Eating in North America*, ed. Ben Zeller, Marie Dallam, and Nora Rubel (New York: Columbia University Press, 2014).

Sante, Luc. *The Other Paris*. New York: Farrar, Straus, and Giroux, 2015.

Strauss, Zoe. *America*. Los Angeles: Ammo Books, 2008.

Taylor, Frank. *Poor Richard's Dictionary of Philadelphia*. Philadelphia: Poor Richard Club of Philadelphia, 1916.

Woodward, Christopher. *In Ruins: A Journey through History, Art, and Literature*. New York: Pantheon, 2001.

Joseph E. B. Elliott is a Professor of Art at Muhlenberg College and an Instructor at the University of Pennsylvania School of Design. He is the author of *The Steel: Photographs of the Bethlehem Steel Plant, 1989–1996* and (with Aaron V. Wunsch) *Palazzos of Power: Central Stations of the Philadelphia Electric Company, 1900–1930.*

Nathaniel Popkin is co-founder of the web magazine *Hidden City Daily* and senior writer for the documentary film *Philadelphia: The Great Experiment.* He is the author of *Song of the City: An Intimate History of the American Urban Landscape* and *The Possible City: Exercises in Dreaming Philadelphia*, as well as the novel *Lion and Leopard*. His literary criticism appears in the *Wall Street Journal* and other publications.

Peter Woodall is a former newspaper reporter and producer for public radio. He co-founded the web magazine *Hidden City Daily* and is the project director of its parent organization, Hidden City Philadelphia.

TEMPLE UNIVERSITY PRESS

Philadelphia, Pennsylvania 19122

www.temple.edu/tempress

Copyright © 2017 by Temple University—
Of The Commonwealth System of Higher Education

Published 2017

All photographs by Joseph E. B. Elliott

Book design by Remake

Library of Congress Cataloging-in-Publication Data

Names: Elliott, Joseph E. B., author, photographer. | Popkin, Nathaniel R.,
 author. | Woodall, Peter, author.
Title: Philadelphia : finding the hidden city / Joseph E. B. Elliott,
 Nathaniel Popkin, and Peter Woodall.
Description: Philadelphia: Temple University Press, 2017. | Includes
 bibliographical references and index.
Identifiers: LCCN 2017021384 | ISBN 9781439913000 (hardback : alk. paper)
Subjects: LCSH: Philadelphia (Pa.)—History. | Philadelphia (Pa.)—Buildings,
 structures, etc. | Philadelphia (Pa.)—History—Pictorial works. |
 Philadelphia (Pa.)—Buildings, structures, etc.—Pictorial works. |
BISAC: HISTORY / United States / State & Local / Middle Atlantic (DC, DE, MD, NJ,
 NY, PA). | PHOTOGRAPHY / Subjects & Themes / Architectural & Industrial.
Classification: LCC F158.3 .E44 2017 | DDC 974.8/11—dc23
LC record available at https://lccn.loc.gov/2017021384

⊗ The paper used in this publication meets the requirements of
the American National Standard for Information Sciences—
Permanence of Paper for Printed Library Materials, ANSI Z39.48-1992

Printed in the United States of America

9 8 7 6 5 4 3